KINGSPORT
CITY OF INDUSTRY

IMAGES of America

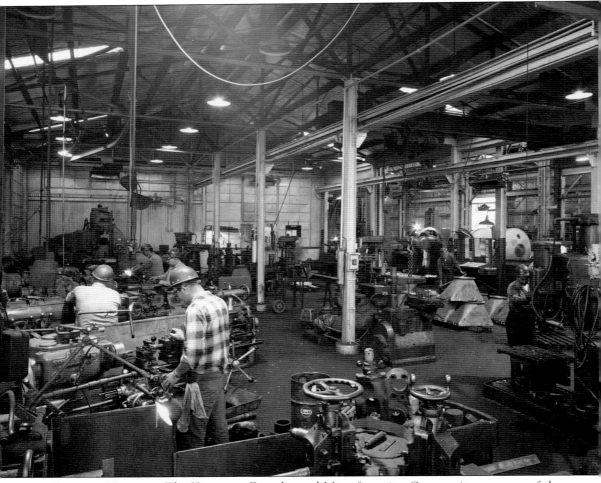

FOUNDRY, UNDATED. The Kingsport Foundry and Manufacturing Corporation was one of the fastest-growing industries in Kingsport. Starting in 1927, the company went through a series of expansions throughout the years and was continuously evolving to meet the needs of the changing industrial environment. The Kingsport Foundry and Manufacturing Corporation employed a number of foundrymen, engineers, and machinists. The corporation was in business in Kingsport until 2003. (Courtesy of the Archives of the City of Kingsport.)

ON THE COVER: KINGSPORT PRESS, UNDATED. For a time, the Kingsport Press had a woodshop in the plant to make wooden packing crates out of lumber. Pictured in this photograph are employees of the Kingsport Press cutting lumber and building crates. The crates would be packed with books to be shipped to places all over the world. (Courtesy of the Archives of the City of Kingsport.)

IMAGES
of America

KINGSPORT
CITY OF INDUSTRY

Brianne Wright

ARCADIA
PUBLISHING

Copyright © 2023 by Brianne Wright
ISBN 9781-4671-6048-3

Published by Arcadia Publishing
Charleston, South Carolina

Printed in the United States of America

Library of Congress Control Number: 2023939817

For all general information, please contact Arcadia Publishing:
Telephone 843-853-2070
Fax 843-853-0044
E-mail sales@arcadiapublishing.com

Visit us on the Internet at www.arcadiapublishing.com

Dedicated to Mitch and Lily

CONTENTS

Acknowledgments		6
Introduction		7
1.	Pioneer Industries	9
2.	Textiles	19
3.	Blue Ridge Glass	41
4	Mead Corporation	49
5.	Kingsport Press	59
6.	Tennessee Eastman and Holston Ordnance Works	77
7.	Food and Beverage Industry	101
8.	Other Diversified Industries	113
Bibliography		126
About the Archives		127

ACKNOWLEDGMENTS

When I set out to compile this book, I was thinking that it would come together pretty easily. The Archives of the City of Kingsport has hundreds of thousands of historical photographs and so much information available. Well, that did not make it easy at all! In fact, there were too many options, which made it difficult to narrow down. Several of the industries highlighted here could have their own book, maybe even two, with the number of photographs and information available. Kingsport is lucky in that regard. The Archives of the City of Kingsport well documents the history of the community. This is in large part due to the contributions and donations to the archives from members of the community. All the images in the book are courtesy of the Archives of the City of Kingsport. First and foremost, thanks go to past, present, and future citizens of Kingsport for your contributions and your support of the archives.

Much gratitude goes to the Friends of the Archives (FOA) for their support and encouragement. It is always good to have friends! All the royalties from this book will be donated to the FOA.

Thank you to Chris Markley, manager of the Kingsport Public Library, and other city officials for their support and recognition of the Kingsport archives. And big thanks to everyone that had a hand in moving the archives above ground.

Special thanks to Sharon Brown for her keen editing skills and for being such an encouraging, supportive, and enthusiastic friend. Also, thank you for reminding me to not be afraid of commas. Thanks to my husband, Mitch, for being the bee's knees. You send my life a whirling . . . for my offering is true.

Lastly, to my daughter, Lily James Wright, be bold, reach for the sky, move mountains, carpe diem, believe in yourself—do all those things and more. Just never forget I will always be there for you.

INTRODUCTION

The history of Kingsport can be divided into two distinct eras: "old" Kingsport and "new" Kingsport. Old Kingsport's history is steeped in its importance as the head of navigation on the Holston River. This area known as the Boatyard District was initially settled in the 1700s when Kingsport was reliant on the river for commerce. Flatboats navigated the river exporting and importing goods from the shipping ports in the area. Diverse industries were established that included oil mills, sawmills, gristmills, saltworks, ironworks, and gunpowder mills. Given the growth and prosperity of the area, the first Kingsport Charter was established in 1822. Several decades later Kingsport was on the verge of disarray. The Civil War had devastated the area's economy, labor force, and spirit. As if that was not enough, the area's reliance on the river had drastically declined because of increasing reliance and interest surrounding the railroad industry. Knowing this, Kingsport advocated to be included on the East Tennessee, Virginia & Georgia Railroad line that would connect Knoxville to Bristol. Ultimately though, Kingsport was bypassed when the railroad went through Jonesborough, which in turn negatively impacted the area. Sometime after this, Kingsport was stripped of its 1822 charter.

"New" Kingsport, more commonly referred to as "Modern" Kingsport, was incorporated in March 1917. It was not born out of a revitalization of the Kingsport that once was. The area outlined as modern Kingsport was located a short distance away and was essentially a clean slate. The impetus of modern Kingsport can be traced back to George L. Carter. Carter, associated with the Carolina, Clinchfield & Ohio Railway (CC&O), was among the first to plant the idea for a modern industrial city. Although Carter owned the railroad and had extensive land holdings in the area, he faced staggering financial difficulties. His financial difficulties led to the sale of the railroad and his holdings to John B. Dennis and the private banking firm of Blair and Company of New York. John B. Dennis, who would later be referred to as the financier of Kingsport, took over the completion of the railroad and then organized the Kingsport Improvement Company. The Kingsport Improvement Company was responsible for the early development and maintenance of the land that had been acquired through the railroad. Carter's brother-in-law J. Fred Johnson became the president of the Kingsport Improvement Company. Johnson is often referred to as "the father of Kingsport" or even the "patron saint of Kingsport." Together, he and Dennis helped make Kingsport become the first privately financed, professionally planned, and economically diversified city in 20th-century America.

One of the biggest factors in Kingsport's success was careful and deliberate planning. The location of Kingsport was ideal for its proximity to a wealth of natural resources. Raw materials like shale, limestone, timber, and water were readily available. The natural resources, availability of transportation, and people to supply labor were essential in the promotion of Kingsport as a potential city of industry. In an attempt to develop industry but avoid many pitfalls that plagued other cities, industrial growth was strategically planned. The idea behind the plan was to diversify the industries established in Kingsport. This would allow Kingsport to not be reliant on one type of

industry and help offset the ebb and flow of industrial demand. Even more important to the plan was the idea of recruiting industries that would be mutually beneficial to one another. Kingsport looked for not only reciprocal industries, but ones that could also function independently. The Kingsport Press is a prime example of this integrated industrial production. A book published by the press could be considered the ultimate Kingsport product. The paper used at the Kingsport Press was made across the street at Kingsport Pulp (later Mead). The book cloth used was made by Holliston Mills, which was located adjacent to the Kingsport Press. The book cloth made at Holliston Mills was manufactured from the gray cloth produced by Borden Mills. Other plants in Kingsport were functionally interdependent on one another, but all of them were financially independent.

Industries were also sought out for how they fit into the practical idealism of Kingsport. It was important that industries provided fair wages and opportunities for skilled and unskilled labor in order to attract and retain workers. The influx of industries and industry workers sparked commercial development. New businesses, including restaurants, clothing and shoe stores, general supply stores, grocery stores, and other service industries were opened. The welfare of the people living and working in Kingsport was an important part of the overall plan. The need for affordable homes and good schools was also recognized as being essential for the growth of a civic-minded Kingsport.

The original planned physical layout of the city, drawn by railroad engineer William Dunlap, was refined by city planner John Nolen. Nolen, a pioneer in the field of city planning, laid out streets and strategically assigned areas of town into industrial, commercial, residential, spiritual, recreational, and educational districts. An important element of the plan was accounting for the growth of the city. They were planning not for what they wanted at the moment, but instead for what they envisioned Kingsport would become.

This book is in no way a comprehensive history of industry in Kingsport or the history of the city of Kingsport in general. The book covers some of the larger, more well-known industries as well as some smaller diversified industries. No matter the size of the industry or product manufactured, they were important to the growth of Kingsport. At one time, it was noted that close to 50 individual products were manufactured in Kingsport at the same time. These products included chemicals, books, paper, cotton, cloth, glass, cement, charcoal, leather, silk, and brick. Products made in Kingsport have been sent to all parts of the world in one capacity or another. Kingsport, however, was not immune to the growing pains that accompanied the building of a city. There were significant housing shortages at different times and significant pollution issues. No city is perfect, but I hope we can agree that Kingsport is a fascinating study of a planned community development and how it all came together.

One

Pioneer Industries

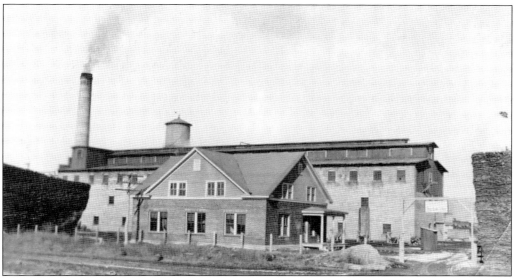

CLINCHFIELD PORTLAND CEMENT, UNDATED. The Clinchfield Portland Cement Corporation was the first major industry in Kingsport. Ground was broken for the million-dollar plant in 1910, and by June 1911, the first load of cement was being shipped out. At this time, electric power and water were not readily available in Kingsport, so the plant had to construct an electric generating powerhouse and drill wells for water.

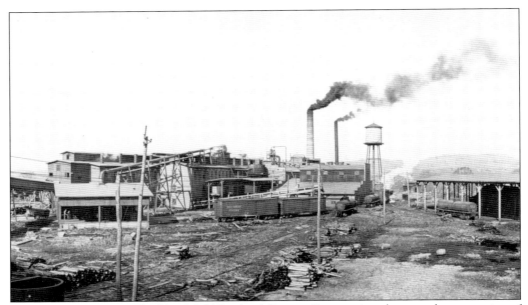

EARLY VIEW, UNDATED. The Clinchfield Portland Cement Corporation plant was the conception of Conrad Miller of Nazareth, Pennsylvania. His son John A. Miller was president of the company. Other management included William Benett, vice president; Felix Guenther Jr., general superintendent; Morris Hunter, sales manager; Conrad C. Miller, assistant sales manager; William Bennett Jr., assistant secretary and assistant treasurer; and E.P. Newhard, chief chemist.

UNIDENTIFIED EMPLOYEE, UNDATED. Located on Hill Avenue, at the foot of Shelby Street, the Clinchfield Portland Cement Corporation started with two kilns and a capacity of 1,400 barrels a day. In 1926, the company merged with the Dixie Portland Cement and Pennsylvania Portland Cement to form Penn-Dixie Cement Corporation. The company built cottages and a clubhouse in the area behind the plant, known as Cement Hill, for visitors and residents.

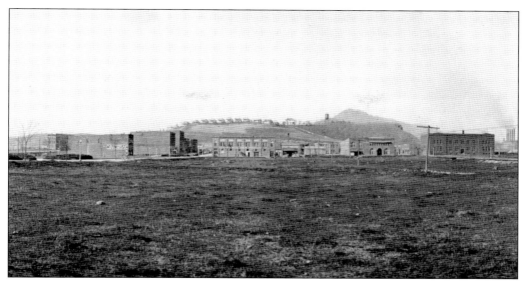

CEMENT HILL, UNDATED. More than a dozen homes were built on Cement Hill throughout the 1920s. In 1924, a footbridge was built over the railroad tracks to allow for easier access to and from Cement Hill and the plant. The main road on Cement Hill, known for a time as Chocolate Row, consisted of red clay and mud mixed with cinders from the plant that gave it a chocolatey look.

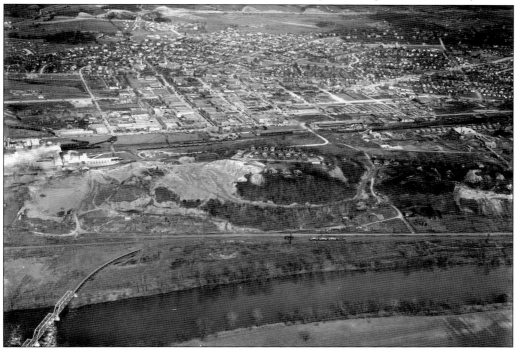

AERIAL OF CEMENT HILL, 1948. In addition to the footbridge, there was also a stairway behind the train station that allowed access between Cement Hill and the plant. The homes were primarily for employees of the plant; however, company policy dictated that widows were allowed to stay in their homes as long as they liked. People continued to live on Cement Hill until the last of the homes were torn down in 1976.

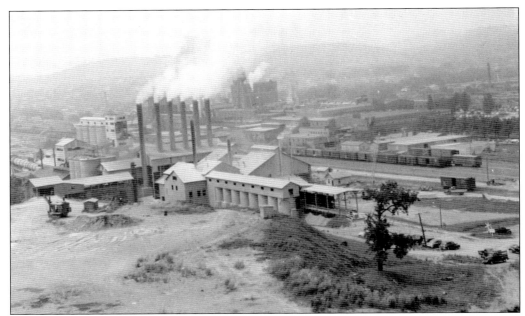

VIEW OF PLANT, C. 1950. Penn-Dixie's location on the Clinchfield Railroad was advantageous for the company. Penn-Dixie depended on railroad transportation for bringing in limestone from its subsidiary, Marcem Quarries Corporation. The Marcem quarry was located just outside of Gate City, Virginia. The limestone was processed with the shale that was quarried at the Marcem quarry to make cement.

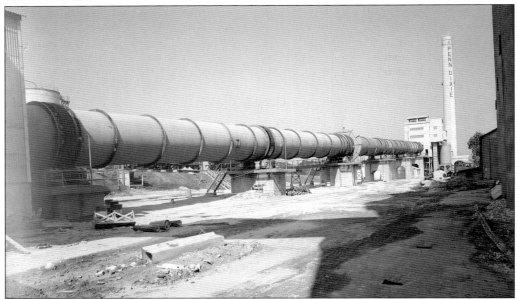

LARGEST KILN, 1951. In 1951, Penn-Dixie installed the largest kiln in America. The kiln was 500 feet long and 12 feet in diameter, making it the largest piece of moving machinery at that time. It produced more than 5,000 barrels, roughly two million pounds of cement, a day. During this time, the plant also converted from a dry to a wet manufacturing process to comply with the city's dust and smoke ordinance.

BASKETBALL TEAM, UNDATED. Most businesses in Kingsport fielded basketball or baseball teams. Penn-Dixie and the Federal Dyestuff Chemical Corporation were among the first to compete against one another. As new industries settled in Kingsport, the number of teams in the industrial leagues grew, and it became necessary to establish a governing board to oversee the rules and policies of the games. The board consisted of men from all the participating industries.

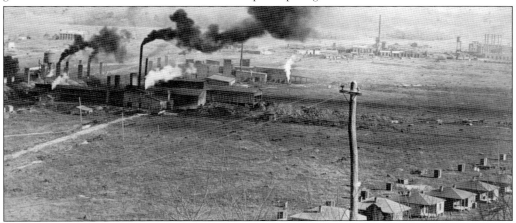

KINGSPORT BRICK, UNDATED. The Kingsport Brick Company was the second major industry located in Kingsport. The location of the plant was beneficial as the company was able to use the raw material, shale, that was located a few hundred yards behind the plant. Construction on the plant started in the summer of 1910. The company was one of the first red-facing brick plants in the South.

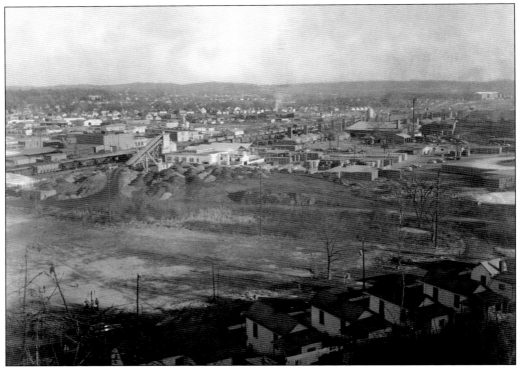

VIEW OF PLANT, UNDATED. The early manufacturing process to make the bricks started with grinding down shale and adding water to it to make a clay. Once the clay was molded into the size and style of brick needed, it was then dried and baked. The Kingsport Brick Company became known for its superiority in manufacturing and the quality of materials used.

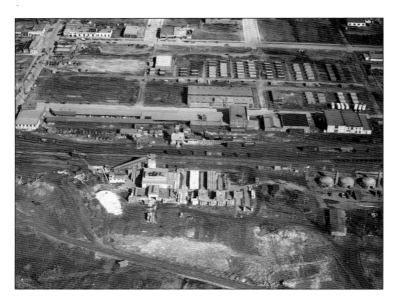

AERIAL VIEW, 1947. In 1927, there were eight different types of brick, and each type was available in three colors. The brick plant manufactured supplies and products for residential, commercial, and institutional construction. Kingsport Brick can be found in a number of homes, churches, businesses, and schools locally and in the Southern region of the United States.

PLANT WORKERS, UNDATED. The Kingsport Brick Company, like many other industrial companies, built homes close to the plant for employees and their families. Some of the homes were located on Hill Street, just west of the plant, and were frame houses. Other homes, east of the plant on Birch Street, were of brick construction. The homes consisted of four to five rooms, a bathroom, and screened porches.

EMPLOYEE, 1956. In the late 1920s, new brick buildings were constructed and new and modern equipment was installed at the plant. Adjacent to the brick plant, a bathhouse was built so workers could clean up after their shifts. In its early days, Kingsport Brick almost exclusively employed local labor, and at one time, the company had less turnover than any other industrial plant in Tennessee.

EMPLOYEE WORKING, 1956. In 1928, General Shale Products of Delaware bought out the Kingsport Brick Company and the Johnson City Shale Brick Corporation, which had been in operation since 1920. The merger formed the General Shale Products Corporation, which began operating in September 1928. In 1929, General Shale purchased several companies, including the Bristol Brick Company, Richlands Brick Company, Jellico Brick and Coal Company, and the Oliver Springs Brick Company.

EMPLOYEE AT WORK, 1956. The first board of directors for General Shale included J. Fred Johnson, John B. Dennis, Sam R. Sells, and E.H. Hunter. The company's first officers were J. Fred Johnson, chairman; Sam R. Sells, president; E.H. Hunter, vice president; J.C. Stone, secretary; and Glen Bruce, treasurer. Glen Bruce also served on the Kingsport Board of Mayor and Alderman both as an alderman and mayor.

ROTARY EXPO, 1945. In 1946, General Shale began manufacturing cinder and concrete blocks using cinders from Tennessee Eastman and cement from Penn-Dixie. To ensure the highest quality, the blocks were tested daily in the company's laboratory. The load-bearing blocks were required to have a minimum strength of 700 pounds per square inch.

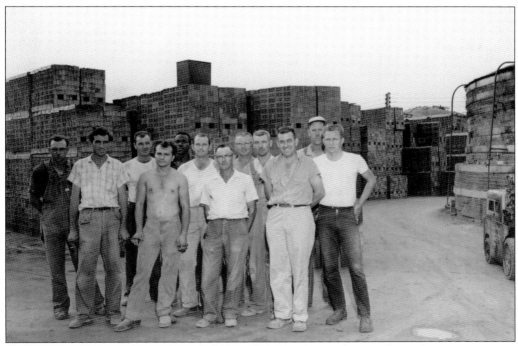

GROUP OF EMPLOYEES, 1965. General Shale today is made up of over a dozen former companies from Tennessee, Virginia, and Kentucky. Headquartered in Johnson City, Tennessee, General Shale is one of America's largest brick, stone, and concrete block manufacturers. With over 25 production sites across the United States, General Shale is still providing a variety of materials for commercial, residential, and other architectural projects.

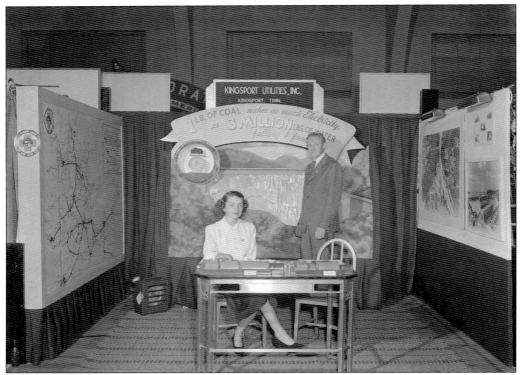

KINGSPORT UTILITIES, 1948. The Kingsport Utilities was a vital industry in the development of Kingsport. As Kingsport grew, so did the demand for electricity. The power produced by the cement plant was not able to keep up with the industrial, commercial, and residential needs of the city. It became necessary to build a power plant to produce and sell power, so the Kingsport Light and Power Company was organized in 1916.

UTILITIES BUILDING, UNDATED. In 1917, the Kingsport Light and Power Company consolidated with the electric facilities of the cement plant and reorganized as the Kingsport Power Corporation. In 1925, the Kingsport Power Company was bought by the American Gas and Electric Company. The Kingsport Utilities building, located on Church Circle, as seen in this image, was constructed in 1932.

Two

TEXTILES

KINGSPORT HOSIERY MILL, UNDATED. The Kingsport Hosiery Mill was incorporated on March 13, 1917. The four-story building was located on the corner of Press (formerly Reedy) and Clinchfield Streets. When the plant began operations, it employed around 85 people and could produce over 26,000 pairs of finished hose daily. Unlike other industries being established in Kingsport at the same time, the hosiery mill provided employment to young women.

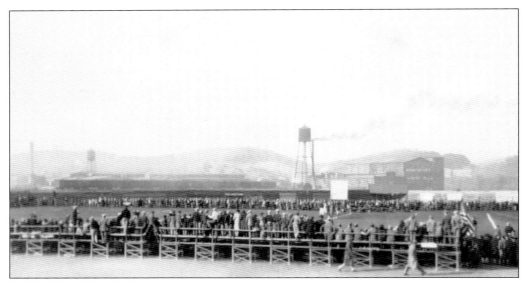

HOSIERY MILL, UNDATED. Employment at the hosiery mill continued to increase, and by 1928, the plant employed more than 400 people, of which 296 of those employees were women. The lunch counter at the mill served free hot coffee daily at noon. In 1932, the Kingsport Hosiery Mill closed, and the building was taken over by the Miller-Smith Hosiery Mill, which remained in operation until 1943.

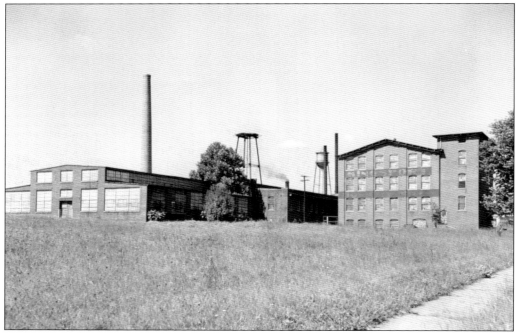

DOBYNS-TAYLOR WAREHOUSE, UNDATED. The hosiery mill property was bought by Dobyns-Taylor Hardware in 1945 and was used as a warehouse for the store. Dobyns-Taylor also rented out parts of the building to the Kingsport Press. Dobyns-Taylor closed in 1985, but the company continued using the building as warehouse space. The mill was placed in the National Register of Historic Places in 2020.

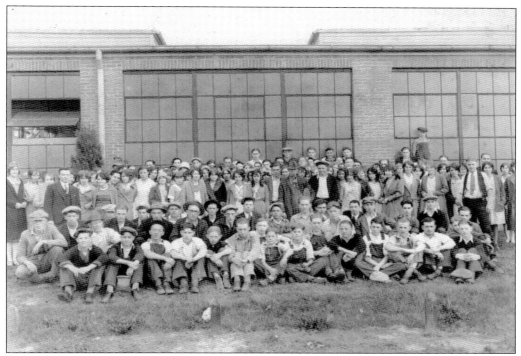

SILK MILL, 1930. The Kingsport Silk Mills began operation in April 1928. The mill was located on West Market Street until a bigger mill was built in Highland Park. The silk mill, owned and operated by a firm based in New York, was managed by Charles Gurney. The silk mill produced radium silk. The name of the mill was eventually changed to Smoky Mountain Hosiery Mills.

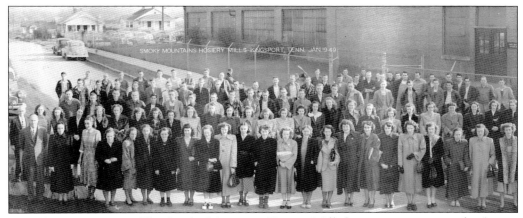

MILL EMPLOYEES, 1930. The Smoky Mountain Hosiery Mills began operations in the former Kingsport Silk Mill location on Berry Street in October 1936. The Smoky Mountain Hosiery Mills was a subsidiary of the Quaker Lace Company out of Philadelphia. The brand name under which the silk and nylon hosiery was produced was Quaker. George Goetsch was the manager, and Ray Bennett was the superintendent of manufacturing.

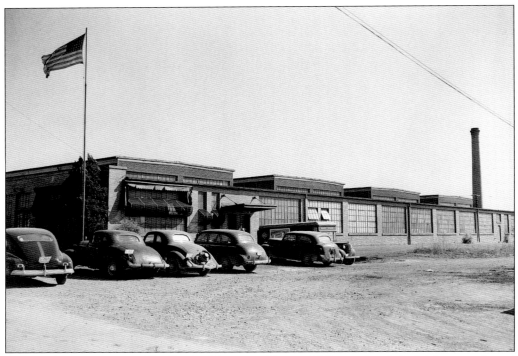

HOSIERY BUILDING, 1946. The Smoky Mountain Hosiery Mills employed the highest number of female workers of any plant in Kingsport. The mill manufactured ladies' full fashion hose. Prior to World War II, the hosiery was manufactured from pure silk thread imported from Japan. During the war, the mill had to change production from silk and nylon to rayon and cotton materials.

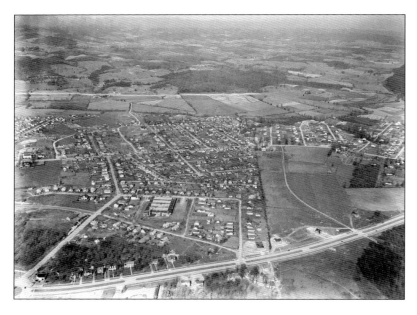

AERIAL OF PLANT, 1948. The Smoky Mountain Hosiery Mills ceased operations and permanently closed on July 17, 1953. At the time of closing, the mill had about 140 employees. The mill closed partly due to economic conditions because of changing feminine fads. Women were just not wearing stockings in the quantity that they once had.

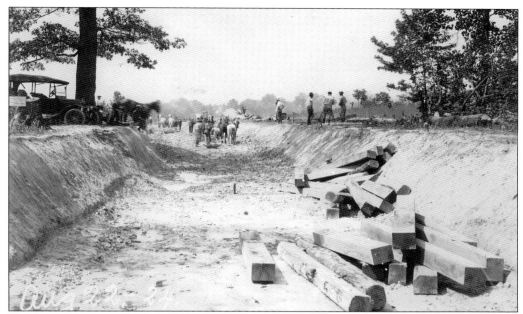

BORDEN MILLS, 1924. Borden Mills, a subsidiary of the American Printing Company from Fall River, Massachusetts, broke ground in Kingsport on August 16, 1924. The first shovelful of dirt was turned by Lulu Lee Cooper Dobyns, wife of Kingsport's first mayor, James W. Dobyns. The original Borden textile enterprise was the Anawan Manufactory in Fall River, which was founded in 1825 by Col. Richard Borden.

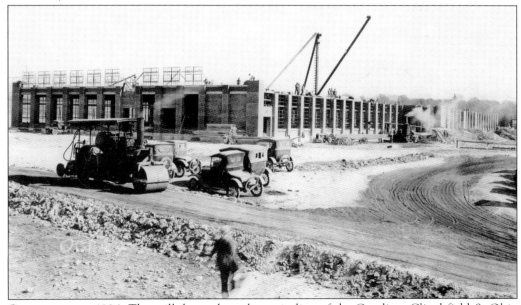

CONSTRUCTION, 1924. The mill, located on the main line of the Carolina, Clinchfield & Ohio Railroad, laid the cornerstone of the main building on October 11, 1924. Present for the occasion were Tennessee governor Austin Peay, Mary and Bertram H. Borden, Gen. Howard Borden, and Mrs. Nathan Durfee of Fall River. The building was designed by George P. Gilmer, an American Printing Company plant engineer.

BORDEN FOREMAN, 1925. To celebrate the laying of the cornerstone, the mayor of Kingsport, J.W. Harrison, proclaimed October 11, 1924, a holiday and urged that activities and businesses be put on hold for the day. Kingsporters were encouraged to decorate their homes with flags and buntings, and a parade was held to welcome executives of the mill and other dignitaries in attendance.

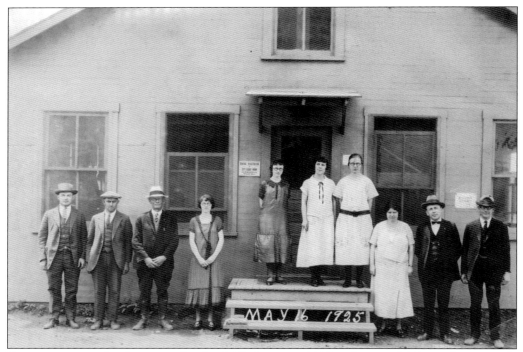

EMPLOYEES, 1925. Production at Borden Mills began in 1925 with around 850 employees. Early production produced roughly 900,000 linear yards of fabric weekly. The cotton warehouse at Borden Mills was six stories high. The first floor contained cotton-opening equipment, and the other five floors were reserved for cotton storage.

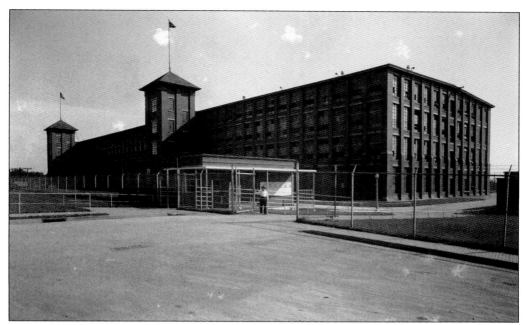

MAIN BUILDING, 1947. The plant's foundation was made of concrete, and the walls were brick. The cement came from Clinchfield Portland Cement, and the brick came from the Kingsport Brick Company. Clinchfield Supply Corporation provided the lumber used in the construction. The plant's main building was 658 feet in length, 147 feet in width, and four stories high.

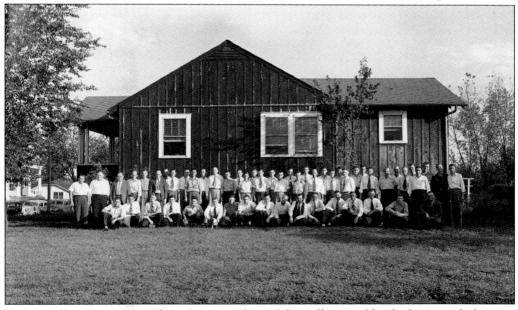

EMPLOYEE PORTRAIT, 1945. The primary product of the mill was unbleached cotton cloth, more commonly known as gray goods. The cloth produced at Borden was baled and shipped to the finishing plant of the American Printing Company, where it was sold to a wide range of customers to use in a variety of products. After Holliston Mills opened, a large portion of the unfinished cloth was sold directly to them.

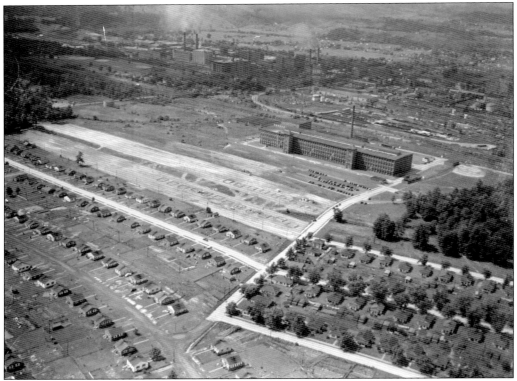

BORDEN VILLAGE, 1947. Recognizing the need for housing, the Kingsport Improvement Company and Borden Mills conceived the idea of building a residential development near the plant. Originally called the Oaks, and later Oakdale Village, the area is now known as Borden Village. By 1950, there were about 400 homes in Borden Village, many of which were designed by New York architect Clinton McKenzie.

BORDEN PARK, UNDATED. In 1928, Kingsport Improvement Company donated over 15 acres to the city to be used as a park and playground. The land between Borden Village and the Borden Mill plant was an ideal buffer for the residential and industrial areas. Originally called Oakdale Park, it was later named Bertram Borden Park after the founder of the Kingsport plant. Today, the park is known as Borden Park.

BASKETBALL TEAM, UNDATED. Borden Mill was often referred to as a model mill, not just because of its size or success, but rather its emphasis and recognition of its employees. Borden Mills had a recreation association meant to sponsor, promote, and execute wholesome recreational activities around the plant and in Borden Village.

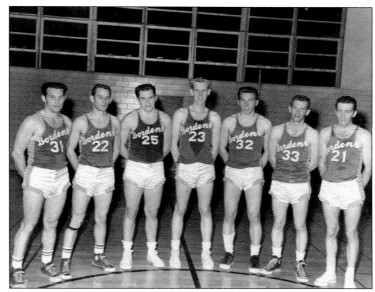

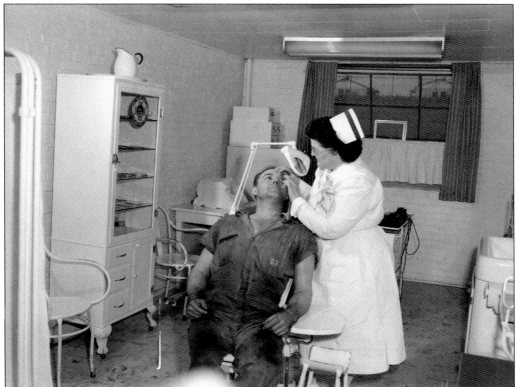

NURSES STATION, 1951. Good health and safety practices were considered essential at the plant. Employees were active in their own safety council, which played a role in reducing the number of workplace accidents. A medical facility was available on-site for treating employees who experienced accidents or illnesses while at work. The company actively looked for ways to improve health and safety in the workplace.

X-ray Machine, 1949. In 1949, the Sullivan County Health Department started a public survey to study unknown causes of tuberculosis. The health department used a transportable X-ray machine to test employees at Borden. Other plants, including Eastman, Holston Ordnance Works, Mead, and the Kingsport Press, also had the portable machine come to their employees. The X-rays were done without charge, and the results were given within a few weeks.

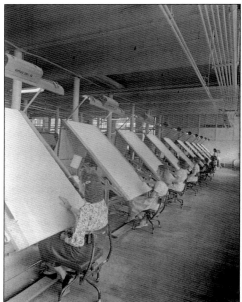

Women Working, 1948. Borden Mills was the first major industrial plant in Kingsport to attain 100 percent participation and 100 percent yardstick during the United Fund Drive for the Kingsport Community Chest. The yardstick was a guide by which contributors donated a certain portion of their pay to reach their goal. The mill also had a credit union that ranked first in Tennessee in the volume of war bonds sold.

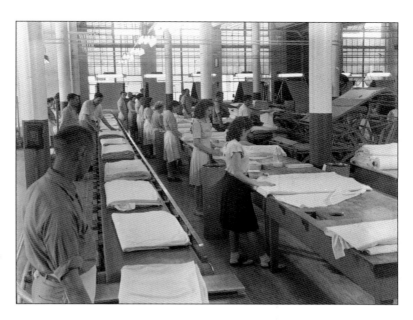

PLANT INTERIOR, 1948. During World War II, close to 90 percent of the plant's production was used directly to assist the war effort. The cotton cloth manufactured by Borden Mills was used to make head nets, gas masks, code wire, shell sealing tape, life rafts, storm suits, food bags, comforters, and both Army and Navy shirts and shorts.

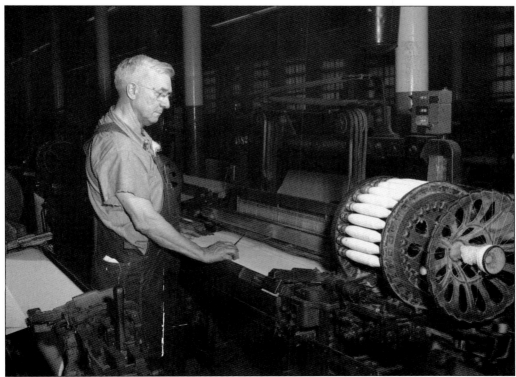

AT WORK, 1951. During the course of the war, Borden Mills earned three Army-Navy "E" Awards. The "E" Award, also known as the Army-Navy Production Award, was given to companies for their excellence in the production of war equipment and military supplies and for their contributions to the war effort. The award was created to encourage industrial mobilization and production of wartime materials.

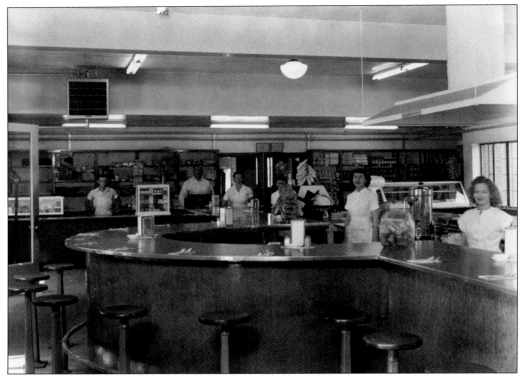

BORDEN CAFETERIA, 1947. The Borden Mills cafeteria system was fairly unique. The main cafeteria was located on the ground floor, but there were also smaller eating areas on other floors throughout the plant. The upper levels used dumb waiters to send items back and forth. The cafeteria also had a lunch wagon that went around to all sections of the plant offering sandwiches, hot and cold drinks, and candy.

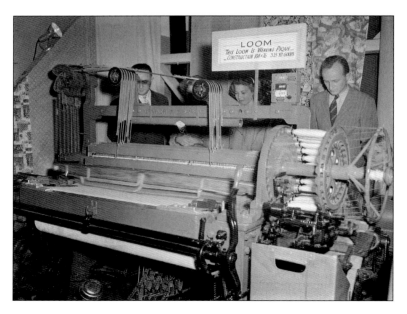

LOOM ON DISPLAY, 1948. The Rotary Club Industrial Exposition allowed Borden Mills the opportunity to display equipment and products from the plant to the public. Technicians from Borden Mills were on hand to supervise, explain, and demonstrate the equipment. Examples of finished fabrics were also on display, and a variety of fabric samples were available.

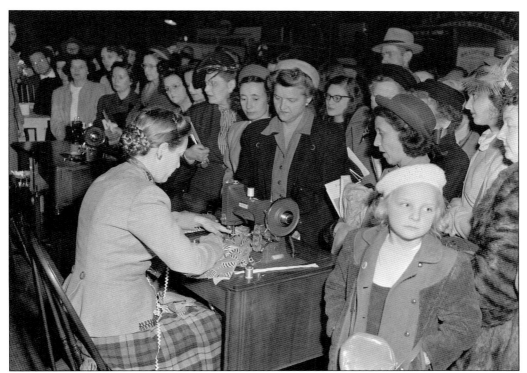

SEWING DEMONSTRATION, 1948. Ada Wallace and Bessie Roberts, from the White Sewing Machine Company, garnered a lot of attention at the industrial exposition for Borden Mills. The two participated in a dress-making contest. The goal was to complete a dress within 30 minutes. They ultimately set a speed record for completing a dress in 20 minutes and 33 seconds. The dresses were distributed as prizes to raffle winners.

WINNERS, 1948. Lucille Rivers, director of the speed competition, was a successful fashion designer. She wrote newspaper columns, hosted a sewing show on television, and traveled the country to give lectures. She was at the expo to present prizes to the winners of the raffle. Besides the completed dress, winners were given gifts for every member of their family, such as kerchiefs for the children and shorts for the men.

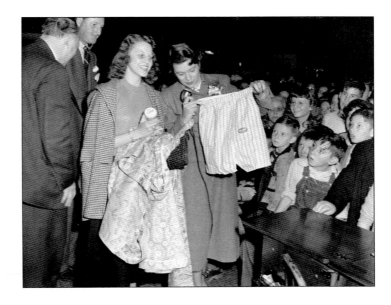

QUALITY CONTROL, 1948. Before the cotton bales were worked, the cotton was put into a cotton classification room. In this room, an employee called a "classer" judges samples of cotton. The classification room was humidity and temperature controlled. The lighting in the room was also monitored to ensure unchanging artificial daylight. The whole process was part of their quality-control procedures.

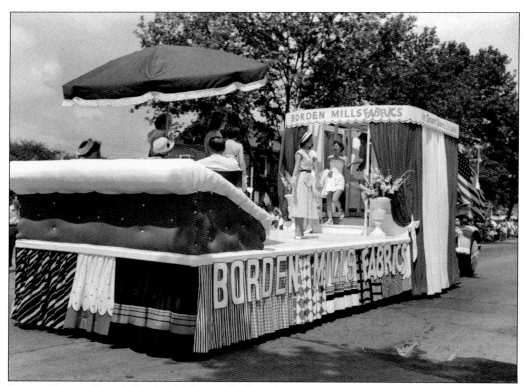

PARADE FLOAT, 1950. A Borden Mills parade float during a Fourth of July parade is seen here with women modeling products made from fabrics produced by the company. Clothing made with these fabrics could be purchased "In Smart Stores Everywhere." Like many industries in Kingsport, Borden Mills participated in a number of community events.

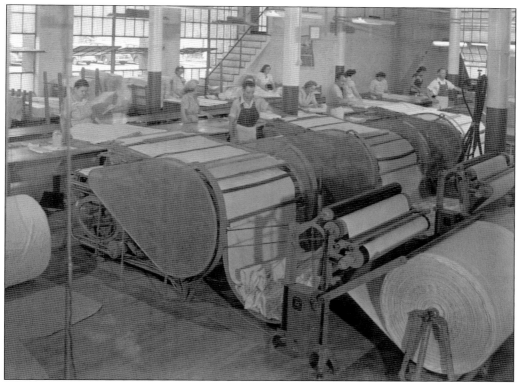

Interior of Mill, 1948. In 1950, a new lap conveyor system was developed to handle heavy laps. Laps were large rolls of cotton from which the carding machines started making cotton thread. The laps were placed on an overhead rail conveyor that used gravity to slide them onto a set of scales to be weighed. The conveyor system was licensed to the American Monorail Company to be manufactured.

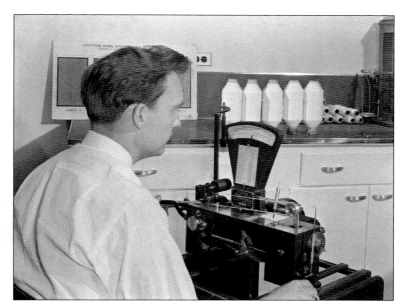

Lab Testing, 1948. A modern, up-to-date control lab at Borden Mills was added to the plant in 1947. Testing of different manufacturing processes was checked at frequent intervals. The tests were conducted by trained technicians. Some of the tests involved the strength of yarns, the moisture content of the cloth, and sizing compounds.

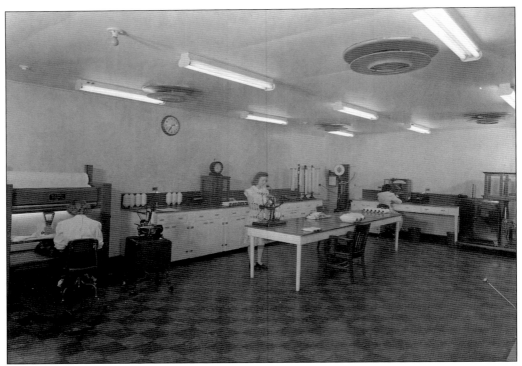

RESEARCH LAB, 1949. Shirley Watson (left) is seen here in this photograph using a lap meter to determine the uniformity of lap weight. Carrie Brandon (center) is reeling yarn to test for strength and weight. Kathyren Penland (right) is conducting a weight check on drawing sliver. Product and material testing was necessary to ensure quality control and compliance with manufacturing standards.

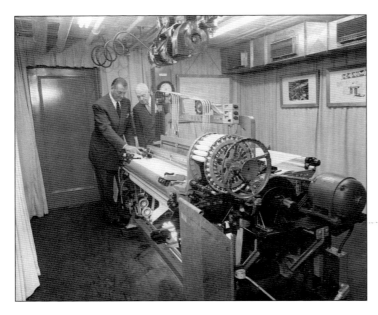

NEW LOOM, 1953. Arthur Borden (left) and Bertram Borden (right) are seen in this photograph inspecting a new, innovative loom. The loom was conceived by John Borden, first vice president of Borden Mills, and William Still, vice president and general manager. The loom was developed by Hunt Loom and Machine Works of Greenville, South Carolina. The H-B-3 (Hunt, Borden, 1953) loom was a major development in the textile industry.

BERTRAM BORDEN, 1953. The H-B-3 loom required no lubrication, which eliminated the constant need for cleaning oil, lint, and other materials. The loom attracted the attention of the textile industry and was made available for purchase. Made by the Hunt Loom and Machine Works, the machines sold for a base price of around $1,500. The company could initially manufacture 45 looms a month.

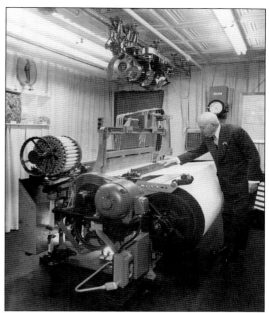

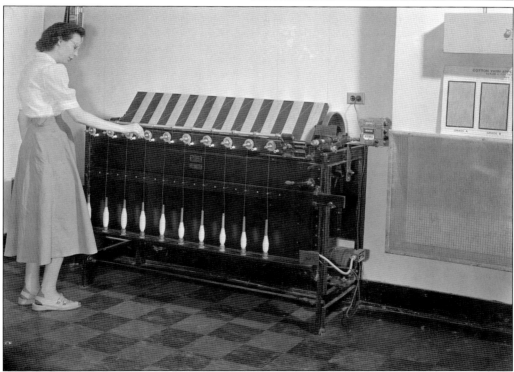

BORDEN EMPLOYEE, 1948. Borden Mills was purchased in 1959 by J.P. Stevens and Company, the nation's second-largest textile manufacturer. Headquartered in New York City, the company owned close to 40 plants and had roughly 25,000 employees. The company spent over a million dollars in modernizing the plant. One of the first things they did was sell the Borden Village homes that were conveyed in the sale.

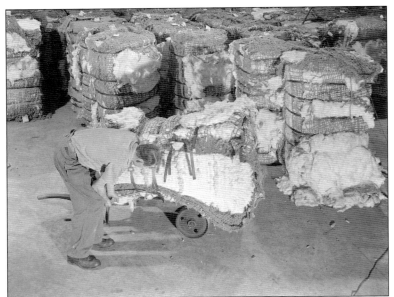

Baling Cotton, 1948. In 1988, the Kingsport plant of J.P. Stevens and Company began operating as JPS Converter and Industrial Corporation, a subsidiary of JPS textile group. The main product of the plant continued to be 100 percent cotton print cloth along with fabrics and yarns containing blends of cotton, rayon, and polyester for apparel.

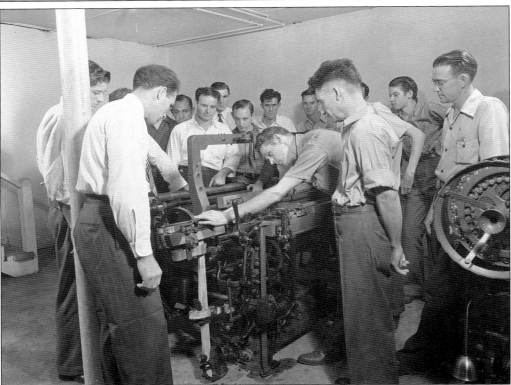

Examining Machinery, Undated. JPS Converter was purchased by Chiquola Fabrics in 1999. Chiquola Fabrics continued manufacturing the same products, including light- to medium-weight woven cotton and blended fabrics. Chiquola Fabrics closed in 2003. Eastman Chemical Company purchased the property, and the building was torn down in 2012. In 2021, Eastman donated a portion of the property to the City of Kingsport to expand Borden Park.

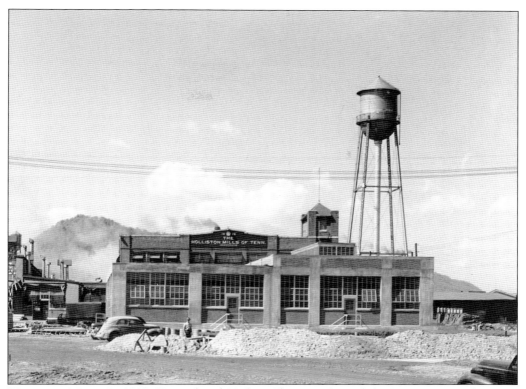

HOLLISTON MILLS. In 1893, Howard and Herbert Plimpton formed the Security Manufacturing Company as a division of the Plimpton Press in Norwood, Massachusetts. In 1895, the name changed to Holliston Mills. The company began with making bookbinding glue. In 1900, a patent was filed for a machine that covered cardboard with fabric, making book covers. With the "machine made for casing-in books," the company began to manufacture bookbinding cloth.

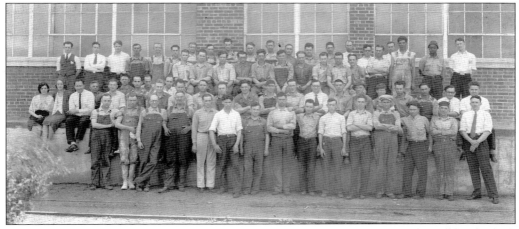

HOLLISTON EMPLOYEES. By 1905, Holliston Mills began manufacturing book cloth of all kind, which became the company's main product. In 1920, Holliston Mills became formally incorporated and branched off from its parent company, Plimpton Press. In 1926, the company expanded and opened a plant and bleachery in Kingsport. The plant, located in two buildings adjacent to the Kingsport Press, became the local source for bookbinding materials.

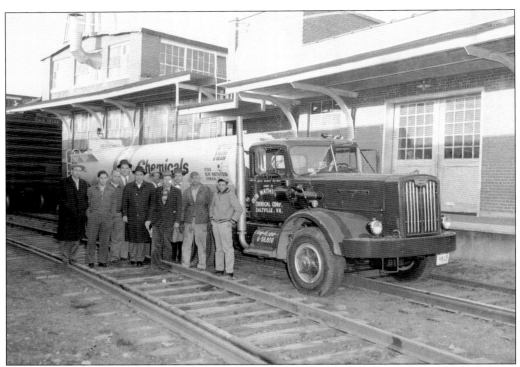

EMPLOYEES, 1957. The proximity of Holliston to Borden Mills and other cotton mills within a few hundred miles of Kingsport was advantageous for the company. The bleachery that was established was supplied mostly from the gray cloth obtained from Borden Mills. The Kingsport Press, right next door, became the company's largest customer of bookmaking supplies. The plant began production with 50 employees.

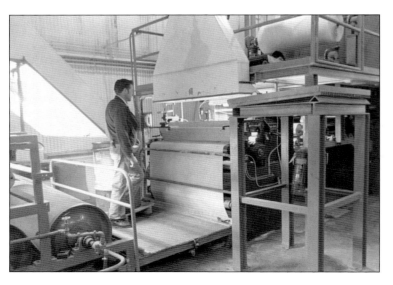

MAN WORKING, UNDATED. At the time of the plant's opening in Kingsport, Holliston Mills was the third-largest book cloth manufacturing company in the United States. The Kingsport location, known as the southern plant, made book cloth known under the names Novolex and Sterling Linen. Holliston Mills also made cloth for lamp shades, labels, and tags.

AT WORK, UNDATED. Prior to Holliston Mills building a modern, stoker-fired boiler plant of its own in 1947, steam from the Kingsport Press had been used. Around this time, Kingsport became increasingly aware of issues with smoke, dust, and other pollution and began to enact environmental ordinances. With the new boiler, along with other adjustments, Holliston Mills was the first major industry in the city to meet the new requirements.

UNIDENTIFIED EMPLOYEE, UNDATED. The Plimpton family sold Holliston Mills and its subsidiaries to Thomas McCusker in 1940. McCusker added two more mills to the company and created new products that were not just for bookmaking. As Holliston Mills grew and expanded, it became the largest producer of book-covering materials in the world. The company shipped its product throughout the United States and to many foreign countries.

Woman Working, Undated. Half of the total book cloth used in the United States was made at Holliston Mills. In 1960, manufacturing at the Norwood, Massachusetts, Holliston Mills plant ceased operations, and all of the manufacturing was done in Kingsport. In October 1962, Holliston Mills purchased approximately 111 acres of land for a new plant located in Hawkins County, about 10 miles from Kingsport.

At Work, Undated. The New Canton plant manufactured book-cover material, fancy packaging, and industrial cloth. They were also the preferred supplier of high-security passport cover material for the US government. Holliston Mills continued to operate its New Canton plant for several decades. In 2017, it was acquired by Holliston Holdings LLC, a Knoxville-based company.

Three
BLUE RIDGE GLASS

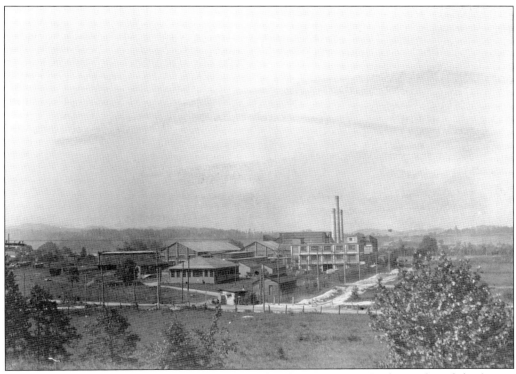

CORNING GLASS, C. 1920. The Corning Glass Works of Corning, New York, purchased the former Edgewood Arsenal property in 1919 to build a factory to house its Southern Division. Production of Pyrex Baking Ware began in Kingsport in the fall of 1920. The heat-resistant baking and serving dishes were manufactured using a patented, secret process. The plant had the capacity of producing over 20,000 pieces of Pyrex daily.

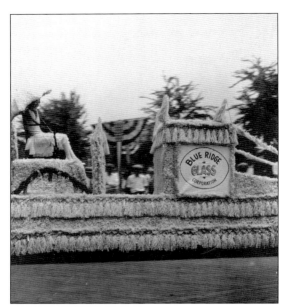

Parade Float, Undated. Kingsport was chosen by Corning for its labor, transportation, water supply, and proximity to an inexhaustible supply of white sand. Despite the success of Pyrex, the Southern Division of Corning Glass Works became inactive in 1921 due to the general economic depression throughout the country. Plans to resume operations never happened. Eventually, the Pyrex plant was revamped for the Blue Ridge Glass Corporation.

Employee at Work, Undated. The Blue Ridge Glass Corporation was formed in 1925 by the merging of three companies: Corning Glass Works, Saint-Gobain of France, and Saint-Roche of Belgium. The first glass manufactured by Blue Ridge was in May 1927. The plant ran three shifts and operated continuously from Monday to noon on Saturday, allowing employees to have Saturday afternoons and Sundays off.

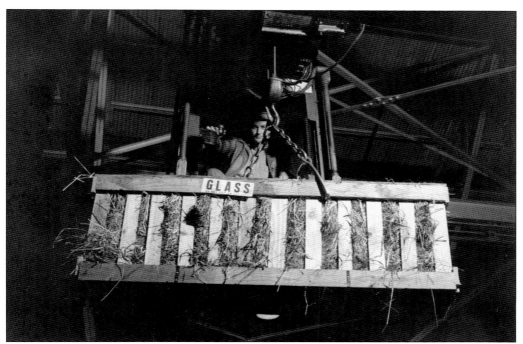

MOVING GLASS, 1946. Like Corning Glass Works, Blue Ridge benefited from the availability of raw materials used in the glass-making process—sand, soda ash, and lime. Fusing the raw materials into glass was done by gas, manufactured from coal, which was available nearby. The lumber from local suppliers was used for shipping crates and boxes.

EMPLOYEE WORKING, UNDATED. It did not take long for Blue Ridge Glass to become one of the world's leading glassmakers. They manufactured a variety of products, including rolled figure glass, glass for factory windows, ornamental and polished glass, and wire glass. Glass from the plant was distributed by the Libby-Owens-Ford Glass Company.

43

At Work, Undated. The Blue Ridge Glass Company was one of the most civic-minded industries in Kingsport. They were one of the first to offer workman's compensation insurance in addition to other policies that covered life, health, and accident insurance. They were also the first industry to start a voluntary blood bank program in Kingsport.

Women at Work, Undated. Given the high temperatures and heavy lifting involved, women were not allowed by the company to be involved in any part of the manufacturing process. The women employed by Blue Ridge Glass were hired for clerical work and food service as these jobs were deemed far safer.

Coffee Break, Undated. Due to the increased need for copper for ammunition and military equipment during World War II, the US Mint had to look at alternative materials to produce pennies. In order to do this, select industries were chosen to experiment with other metals, plastic, and rubber to make pennies. Blue Ridge Glass, in alliance with Corning Glass Works, was chosen to make glass pennies.

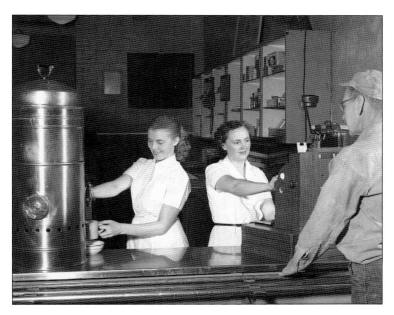

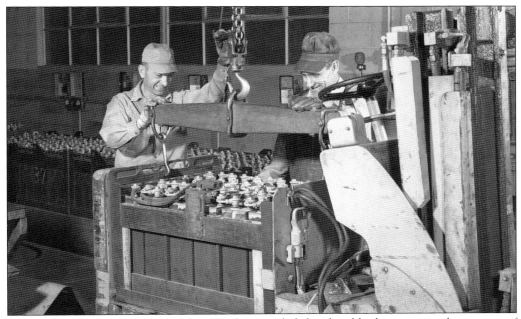

Employees, Undated. Corning Glass Works provided the glass blanks to use in the process of designing the pennies and then Blue Ridge Glass would stamp them. The dyes used were prepared by John Sinook, a US Mint engraver. Unfortunately, the glass penny experiment failed, and they never made it past the prototype. The pennies could not be made a uniform size or weight, and they broke too easily.

CHECKING EQUIPMENT, UNDATED. Test pennies from different industries were made from bronze, brass, zinc, zinc-coated steel, manganese, white metal, aluminum, lead, rubber, fiber, and plastic. Ultimately, in 1943, zinc-coated steel was used. Blue Ridge Glass made an unknown number of test pennies from a hardened yellow amber glass. There is only one known intact experimental glass survivor. It sold at auction in 2017 for over $70,000.

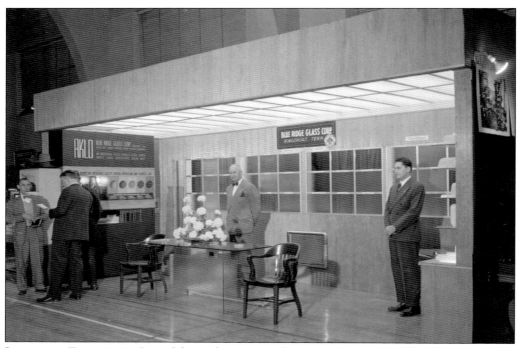

INDUSTRIAL EXPO, 1948. One of the trade name products manufactured by Blue Ridge was Aklo. Aklo was a heat-absorbing, glare-reducing glass of blue-green color. It was primarily used for offices and factories to reduce heat. Other names of glass manufactured by the company included Lourex, Flutix, and Doublex.

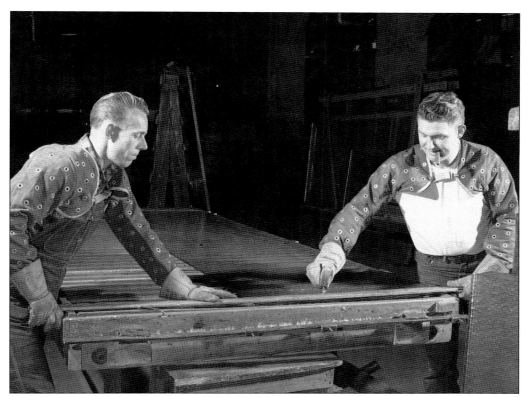

PLANT WORKERS, UNDATED. In 1955, Blue Ridge Glass became wholly owned by Saint-Gobain, and in 1958, Blue Ridge was merged with American Window Glass of Pittsburg. The merger created the American-Saint Gobain (ASG) Corporation. At the time of the merger, the company began looking for a new site to build a new $50 million glass plant. In 1960, a 700-acre site just outside of Kingsport was selected.

GLASS PLANT EMPLOYEES, UNDATED. The new plant, referred to as the Greenland plant, was located in Hawkins County and opened in 1962. In 1978, American-Saint-Gobain merged with Fourco Glass and became known as AFG. AFG was the largest supplier to the construction and specialty glass markets. In the late 1990s, AFG merged its Canadian plant into its North American operations. This acquisition brought the total number of manufacturing plants to eight.

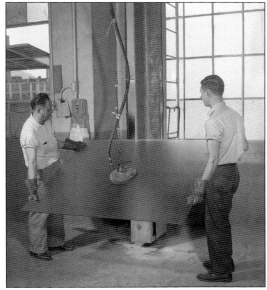

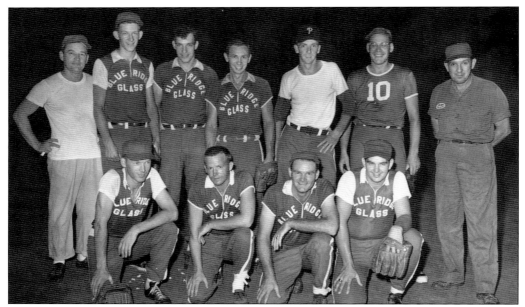

BLUE RIDGE TEAM, UNDATED. In 2006, the corporate headquarters of Blue Ridge Glass moved from Kingsport to Atlanta. In 2007, the name changed from AFG to AGC Flat Glass North America. AGC stood for Asahi Glass Company. AGC Flat Glass operated the Kingsport glass plant site until 2012. The Greenland plant continued operations and underwent an expansion in 2018. In 2021, the company was purchased by Cardinal Glass.

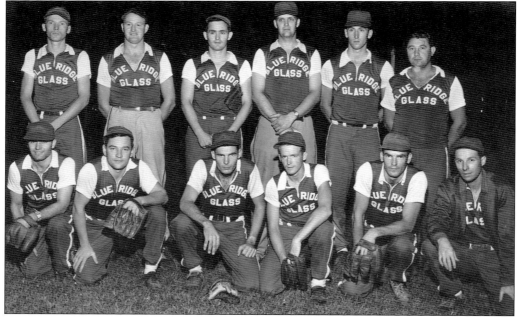

BASEBALL TEAM, 1953. Members of the Blue Ridge Glass Industrial League team are (first row, from left to right) Roy Crabtree, Bob Moore, Ray Arnold, Austin Adams, C.C. McConnell, and Sam Norris; (second row, in no particular order) unidentified, Charles Purdue, Ray Grills, J.B. Hammonds, C.K. Rowan, and manager John Crumley.

Four
MEAD CORPORATION

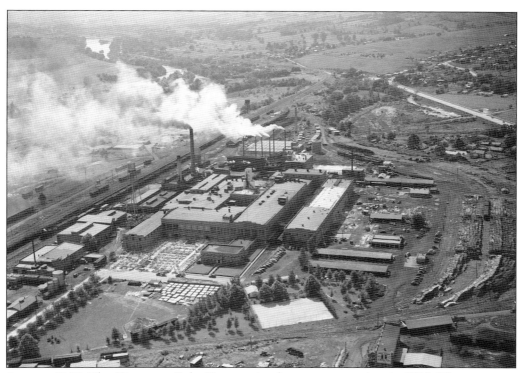

AERIAL, 1946. The Kingsport Pulp Corporation began construction in 1916. The company, located on Clinchfield Street at the end of Main Street, made pulp to make paper from wood waste. Strategically, the plant was located in Kingsport because the existing Kingsport Extract and Tannery could provide over half of the needed raw material: extracted chestnut wood chips.

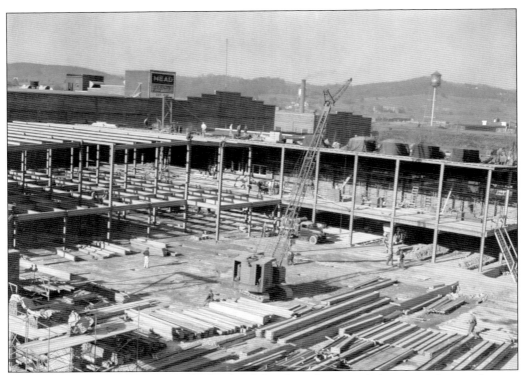

EXTERIOR CONSTRUCTION, 1946. The locale of the plant also provided a means for an adequate power and water supply. It was able to operate its own water filtration plant by pumping water directly from the Holston River. It was also able to power the plant with its own steam plant. The plant was designed to produce 50 tons of soda pulp per day.

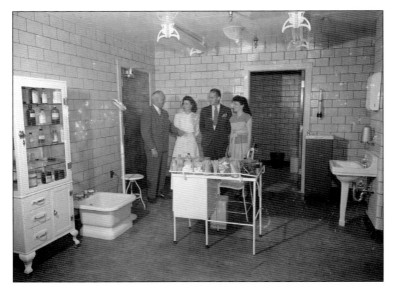

CLINIC, 1947. Construction of the plant was started under the supervision of Royal B. Embree of Buena Vista, Virginia. Embree came to Kingsport from the Columbian Paper Company to be president of the Kingsport Pulp Corporation. Other management included J.H. Thickens, general manager; J.E. Wetherbe, manager; and J.C. Stone, treasurer.

MOVING LOGS, UNDATED. George Mead of the Mead Pulp and Paper Company invested $100,000 into the Kingsport Pulp Corporation in 1916. In 1920, the plant was purchased by the Mead Pulp and Paper Company from Chillicothe, Ohio, and the name was changed to Mead Fibre Company. Prior to 1922, the pulp plant exclusively manufactured soda pulp and shipped the product to paper plants to be manufactured into paper.

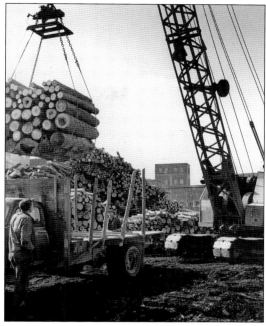

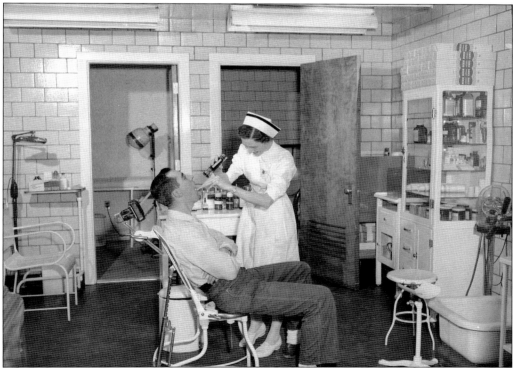

NURSE'S OFFICE, 1957. Around 1923, Mead went through an expansion that included adding papermaking and finishing facilities. These new facilities allowed the plant to use the soda ash produced there to manufacture white paper. A major portion of the pulp produced at Mead was kept in-house to make paper. The remaining pulp was still being marketed and sold to other paper plants.

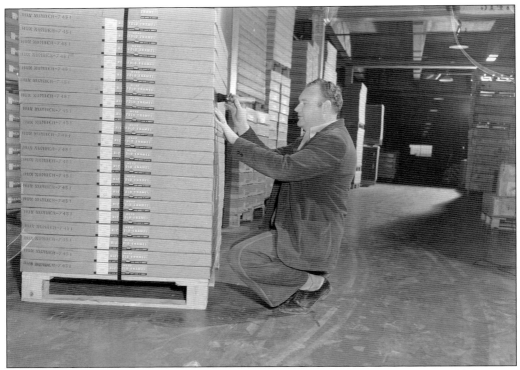

EUGENE PHILLIPS, 1954. The Mead Sales Company, which had been formed in 1921, sold the paper produced by the plant. It was during this time that the J.J. Little and Company, operating as the Kingsport Press, was established in Kingsport. The press was able to utilize the paper made at Mead and would eventually become their biggest customer.

CAFETERIA, 1962. In the 1920s, researchers at Mead discovered a semi-chemical pulping process where wood chips that had the tannin extracted from them could be converted into paperboard. Shortly after this discovery, the Mead Paperboard Corporation was founded. Paperboard included the manufacture of kraft and secondary fiberboard and its conversion into different forms of packaging and shipping containers.

PLANT INTERIOR, 1954. In 1931, the Mead Corporation was incorporated with George Mead as the appointed president. George Mead had begun his career in the paper industry in 1897 in a mill founded by his grandfather Col. Daniel E. Mead. With the incorporation, the Kingsport plant joined other divisions and subsidiaries of the corporation from different states for the manufacture of pulp, paper, paperboard, and chestnut extract.

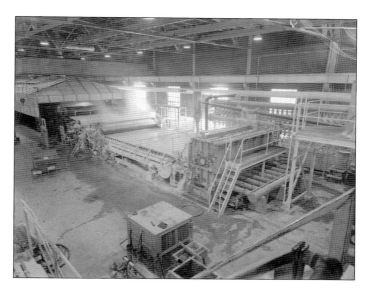

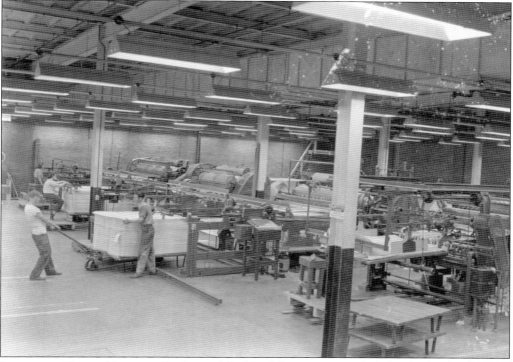

INTERIOR OF PLANT, UNDATED. Products of the Mead Corporation included pulp, fine book paper, magazine paper, and technical papers. The magazine paper produced by Mead was used in magazines such as *Times*, *Sports Illustrated*, *Reader's Digest*, *Look*, *McCall's*, *House and Garden*, *Red Book*, *World Report*, *Popular Science*, *U.S. News*, and other national magazines.

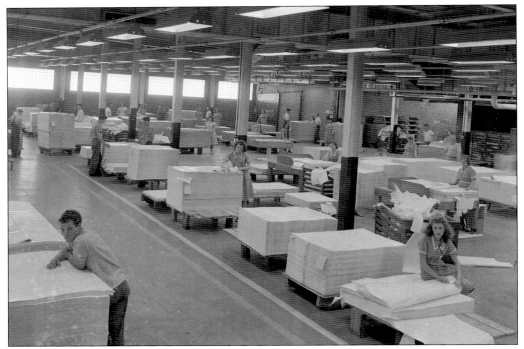

INSIDE PLANT, 1948. Paper from Mead could be found in various textbooks, novels, and illustrated literature produced by the Kingsport Press. During World War II, paper and paper products were accelerated to provide armed forces with strong, lightweight, waterproof maps and training materials. After the war, the plant went through a modernization process that included plans to comply with the city's smoke and dust ordinances and to reduce stream pollution.

MEAD AUDITORIUM, 1961. George Mead never lived in Kingsport but took an active role in the community. In November 1961, the City of Kingsport held a dedication for the J. Fred Johnson Memorial Library and the George Mead Auditorium. This is a photograph of Ford T. Shepard (Mead), Genevieve Shivell (chairman of the library commission), and V.K. Shanon (Mead) standing in front of a portrait of George Mead.

BASKETBALL TEAM, UNDATED. The "Papermakers of America," as Mead was known, manufactured more than just paper. In addition to paper, Mead made and sold liner board, corrugating medium, and finished corrugated shipping containers. The packaging division made food containers and other consumer packaging items. Another division within Mead made various specialty papers.

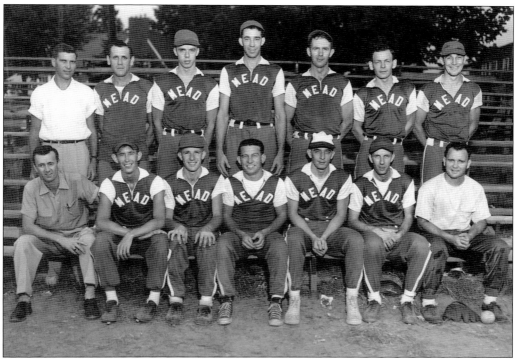

BASEBALL TEAM, 1953. Members of the Mead baseball team seen here include, from left to right, (first row) team manager Glynn Poteet, Bill Mckay, Bill Cole, Bob Archer, "Buster" Fogle, Harold Compton, and Sherman Warren; (second row) team manager Roy Harmon, Coleman Reeves, "Jiggs" Willis, Rex Jackson, Harlan Harrison, Oscar Harkelroad, and Marvin Salley.

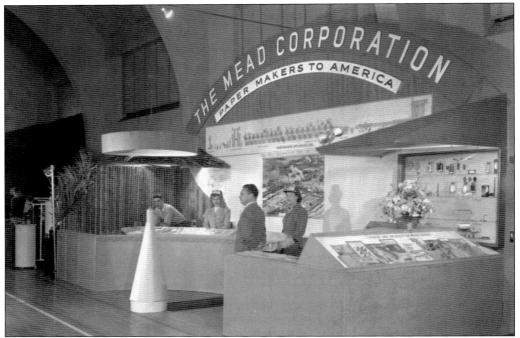

INDUSTRIAL EXPO, 1957. In 1995, Mead sold the Kingsport mill to Willamette Industries and, in turn, purchased over 60 acres of the Penn-Dixie property, including Cement Hill. In 2002, Willamette merged with Weyerhaeuser, a lumber and paper company based in Portland, Oregon. They were the largest integrated manufacturer and marketer of uncoated paper in North America.

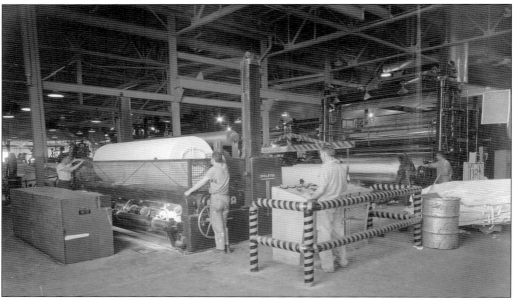

PLANT INTERIOR, 1954. On March 7, 2007, the Weyerhaeuser's Kingsport mill, and other assets within the company, became part of Domtar. Domtar was founded in 1884 as Burt, Boulton Holding Ltd. by Henry Potter Burt in England. With the success of the company, it began expanding throughout Europe and North America. The company's name was changed to Domtar Incorporated in 1977.

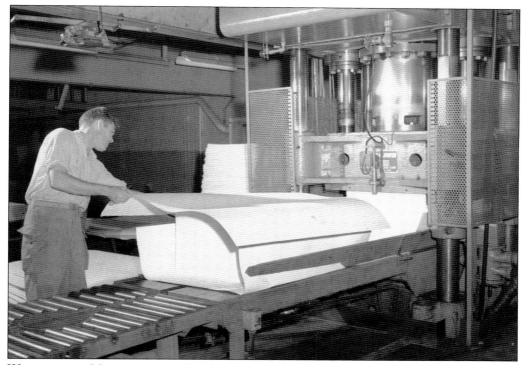

WORKING WITH MACHINERY, 1957. In 2009, Domtar donated land adjacent to the plant and helped to develop the Regional Center for Advanced Manufacturing (RCAM). RCAM promotes STEM (Science, Technology, Engineering, and Mathematics) education and manufacturing skills for students that may be interested in a career in manufacturing. RCAM is affiliated with Northeast State Community College (NSCC).

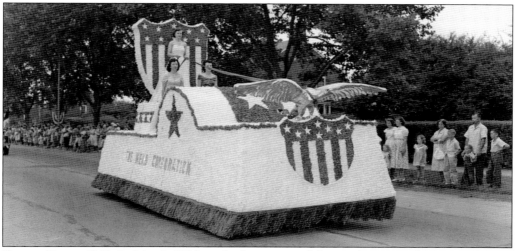

PARADE FLOAT, 1950. In March 2020, at the beginning of the pandemic, production at Domtar idled. In April, production shut down, and over 300 employees were laid off. A decision was made to enter the containerboard market. Domtar proceeded to undergo a two-year, $350 million conversion project. The objective was to convert the plant from an uncoated, free-sheet paper mill into the company's first 100 percent recycled packaging plant.

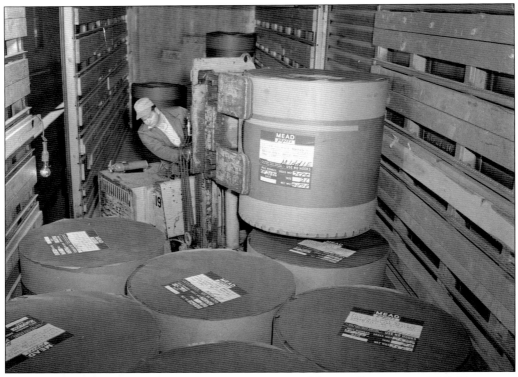

Moving Containers, 1957. Domtar reopened in 2023. With the conversion of the plant complete, Domtar was able to produce and market about 600,000 tons of recycled liner board and corrugated medium a year. As the largest recycling manufacturer in Tennessee, Domtar is preventing over 50,000 tons of recycling residuals and by-products from entering landfills each year.

Women at Mead, 1951. As part of the conversion project, Domtar and the City of Kingsport participated in a land swap. Domtar received Cloud Park and Scott Adams Memorial Skate Park located on Center Street. Kingsport received roughly 40 acres of land on Cement Hill. Domtar helped plan and finance the relocation of the skate park to Brickyard Park.

Five

KINGSPORT PRESS

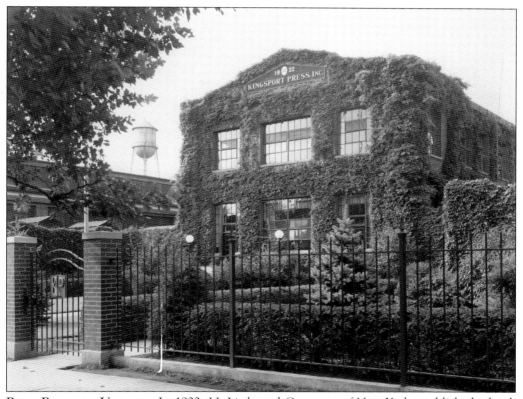

PRESS BUILDING, UNDATED. In 1922, J.J. Little and Company of New York established a book manufacturing plant in Kingsport under the trade name Kingsport Press. Louis M. Adams was president. The plant was built to produce and distribute a series of small clothbound noncopyrighted classics to Woolworths. The books were sold in the chain of five-and-dime stores and by mail order for 10¢ a copy.

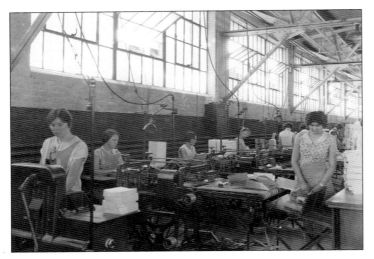

WOMEN AT WORK, UNDATED. The Kingsport Press initially began in vacant buildings that had been constructed by the Simmons Hardware Company to manufacture harnesses and saddlery. The Kingsport Press purchased the property and buildings as a home for its new book manufacturing plant. The property, the size of a city block, was bound by Center, Clinchfield, Roller, and Reedy Streets.

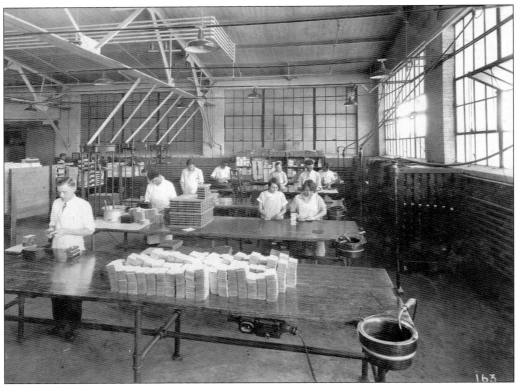

BOOKMAKING, UNDATED. Once in operation, the Kingsport Press was able to manufacture low-cost books for mass distribution. In January 1923, the Kingsport Press received its first order; 50,000 copies of the New Testament. Around 1925, the company was reorganized and became the Kingsport Press Incorporated. It was at this time that Col. E.W. Palmer succeeded Louis M. Adams as president of the company.

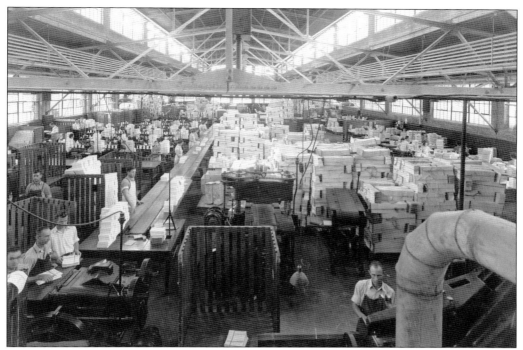

PLANT INTERIOR, UNDATED. The Kingsport Press manufactured its own book cloth through its small book cloth production called Clinchfield Mills. With Clinchfield Mills, the Kingsport Press was able to produce what it needed based on the quality and price of its dime-store books. During the reorganization of the Kingsport Press, the plant began a shift toward manufacturing a variety of books and away from the 10¢ classics.

INTERIOR FACILITIES, UNDATED. Unable to meet the need for higher-quality book cloth fabric, Clinchfield Mills was shut down, and the company began purchasing from Holliston Mills. Holliston Mills, a new book cloth manufacturer adjacent to the Kingsport Press, became its source of book cloth, and the Kingsport Press became its biggest customer. The Kingsport Press also purchased its paper from the Mead Corporation, which was located across the street.

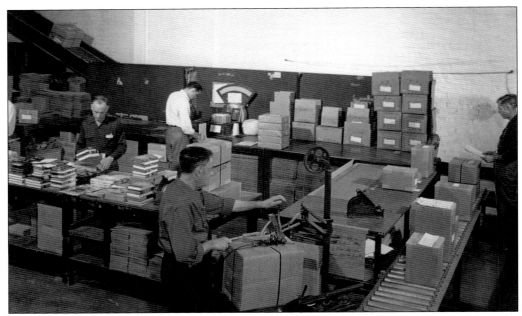

PACKING BOOKS, UNDATED. As the products manufactured by the Kingsport Press shifted from the specialized line of books to more diverse products, there was an increased need to market the book manufacturing firm. A sales office was opened in Chicago, and distribution centers were opened in Chicago and New York. The Kingsport Press Sales Agency marketed to virtually all publishing houses in the United States.

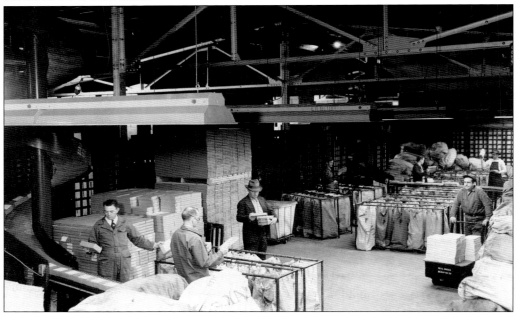

POST OFFICE, UNDATED. To handle the amount of mail produced by the Kingsport Press, the US Post Office established a branch office at the plant. The branch office was maintained by employees of the US Post Office for parcel post only. They oversaw the sorting, packaging, shipping, and loading of several cars a day. The shipping and traffic department was responsible for all the other shipments.

SMALLEST BOOK, UNDATED. The Kingsport Press once produced "America's Smallest Book." The miniature books were designed by employee Hal "Red" Newman in 1927 as part of a training class. Students were required to plan and prepare a project before graduating from the course. Management was impressed with the small book and recognized it would make a clever novelty item to use for advertisement.

HAND SEWING, UNDATED. Three titles of the miniature books were produced: *Addresses of Abraham Lincoln* (1929), *The Autobiography of Calvin Coolidge* (1930), and *Washington's Farewell Address* (1932). The miniature books had to be gathered, sewn, and glued by hand. Although the book was very small, the print was still legible to the naked eye. The miniature books won a prize at the International Book Binding Convention.

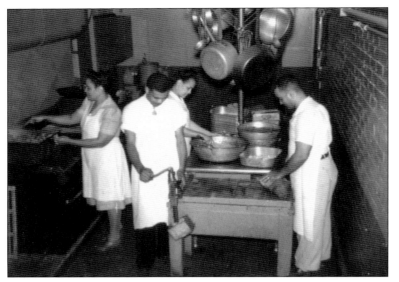

CAFETERIA CREW, 1946. Employees in the cafeteria department seen in this photograph are, from left to right, Jennetta Ligon, Jack Burnette, Ada Stinson, and Joe Stinson. During the late 1940s, the cafeteria served over 750 meals a day. Day shift hours were 7:00 a.m. to 4:30 p.m. while the night shift hours were 6:30 p.m. to 4:00 a.m.

COLONEL PALMER, 1948. During World War II, Col. E.W. Palmer served as the deputy director of the War Production Board's Printing and Publishing Division. During this time, the press printed Bibles and instruction manuals for US troops. Due to his work with the government during the war, Palmer was awarded the honorary rank of colonel and received the Legion of Merit for his service.

OFFICE, 1948. During World War II, the Kingsport Press was authorized to manufacture wartime materials of a highly restricted nature. The company worked with the US Ordnance Department to train workers in the reproduction unit at the Y-12 plant in Oak Ridge on how to produce top-secret documents. After the war, the Kingsport Press was honored by the American Legion for being the top plant in Tennessee in hiring disabled workers.

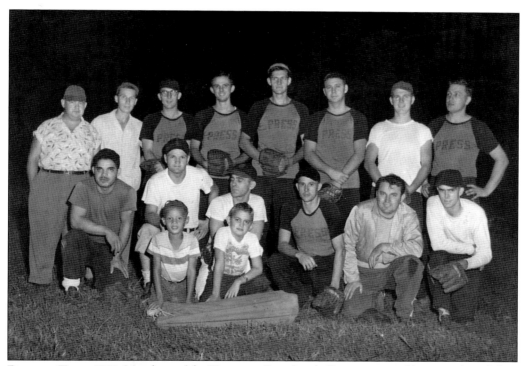

BASEBALL TEAM, 1952. Members of the Kingsport Press baseball team pictured here are, from left to right, (first row) batboys ? Smith and ? Rhoten; (second row) Henry Patterson, Bobby Taylor, Charles Heffner, "Johnnie" Johnson, Laddie Harwood, and Thurman Pease; (third row) "Fat" Aesque, Sam Norris, Herschel Cooper, Jack Rhoten, J.O. Light, Ed Bedford, Paul Lucas, and manager Festus Maddox. The team placed second in the Kingsport tournament.

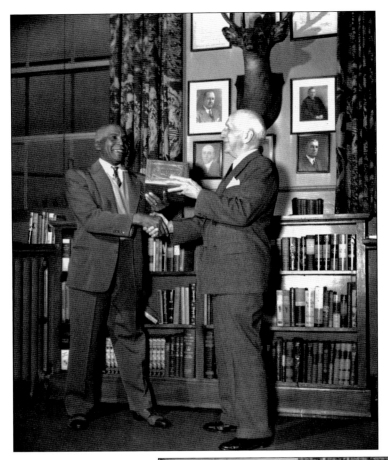

SERVICE AWARD, 1953. William "Eudaley" Trammell is pictured here receiving an award from Col. E.W. Palmer, president of the Kingsport Press. Trammell was recognized for 25 years of service with the Kingsport Press. Trammell, married to Inez (Ross) Lee Trammell, worked in maintenance until his retirement in 1957. Palmer served as president of the Kingsport Press until his death in 1953. Walter F. Smith succeeded Palmer as president.

WALTER SMITH, UNDATED. Walter Smith was born in Gardner, Illinois. He came to Kingsport in 1923 to work at the Kingsport Press, having previously worked in the industrial chemistry field. While at the Kingsport Press, Smith held successive positions from assistant to the president, vice president and treasurer, director, executive vice president, and treasurer and then served as president from 1953 to 1961. Edward J. Triebe succeeded Smith as president.

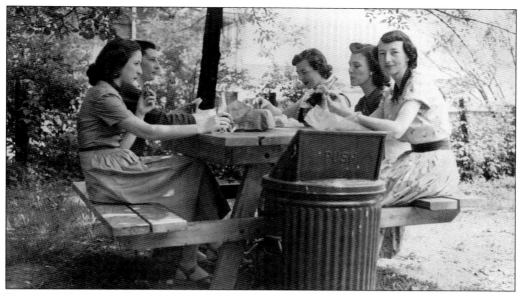

PICNIC, 1953. Pictured here are, from left to right, Jo Helton, Margaret Prince, Eunice Stata, Inez Bedford, and Inis Price enjoying lunch on new picnic tables. Like other industries in Kingsport, the press recognized the need for a balance between work and recreation. There were several recreation spaces in and out of the plant, a number of clubs, athletic activities, and a recreation committee that planned dances, parties, and picnics.

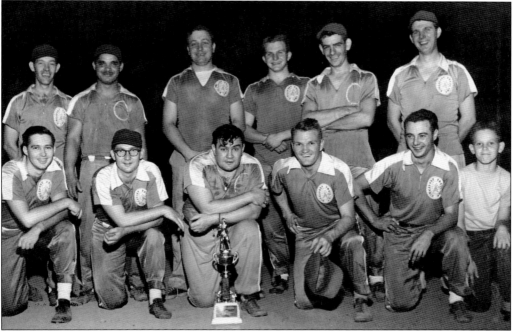

CHAMPIONS, 1954. The Kingsport Press baseball team won the city league championship during the 1954 season. From left to right are (first row) Jack Marsh, Herschel Cooper, Ted Hill, Bob Taylor, Winky Lucas, and Jack Kendricks, who acted as batboy for the whole season; (second row) Ray Morgan (manager), Henry Patterson, Festus Maddox, Glen Williams, Don Solt, and Paul Lucas.

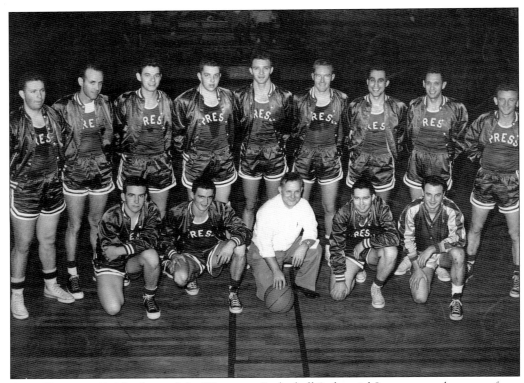

PRESS TEAM, 1956. Members of the Kingsport Basketball Industrial League seen here are, from left to right, (first row) Frank Miller, Frank Bolling, Claude Smith, Jack Marsh, and Lloyd Lucas; (second row) Bob Bedford, Fred Gray, Jim Ellis, Ed Cookenour, Ernie Tymon, Charlie Barton, Ivan Jones Jr., Roscoe Fletcher, and Bill Cox.

QUILLEN, 1959. From left to right are John Hicks, bindery superintendent; James "Jimmy" H. Quillen; and Congressman William H. Ayres. Congressman Ayres, a representative of Ohio, toured the Kingsport Press during a visit to Kingsport. Quillen, at the time a member of the Tennessee General Assembly, was elected to Congress in 1962. Jimmy Quillen served more than 30 years of uninterrupted congressional service, a record in Tennessee political history.

Employees, 1959. Posed for a picture are, from left to right, W.J. Donnelley, Fred L. Bryant (who was the Southeastern manager of the Miehle Company), unidentified, Johnny Johnson, and Russell Beals (who was the first shift pressman on Press No. 57). The group of men were celebrating the installation of the first roll stand that was installed on a rotary perfector press.

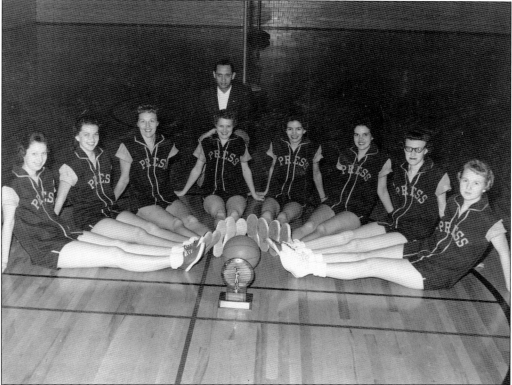

City Champs, 1959. The Kingsport Press women's basketball team claimed the city league championship title during the 1958–1959 season. The team included, from left to right, (first row) Boots Bowen, Anne King, Joyce Bullock, Gladys Gilbert, Peggy Morley, Betty Jenkins, Reva Castle, and Violet Jones; (second row) coach Ross Fletcher. The press team lost only two games over the season. Betty Jenkins, team captain, averaged 24 points a game.

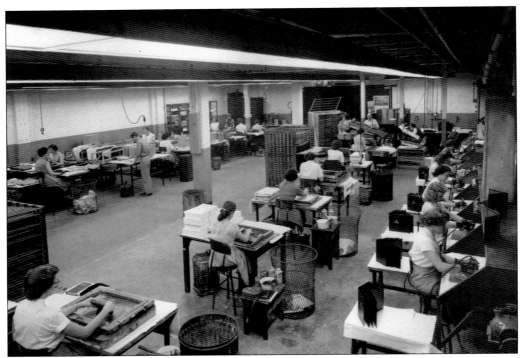

KINGSKRAFT SUPERFINISH DEPARTMENT. Kingskraft, trademarked by the Kingsport Press, was a line of custom book covers primarily used for high school and university yearbooks, reference materials, and other educational materials. The covers, airbrushed or silk-screened and embossed, were prepared by the art department within the superfinish division. The department's slogan was "Kingskraft Everywhere."

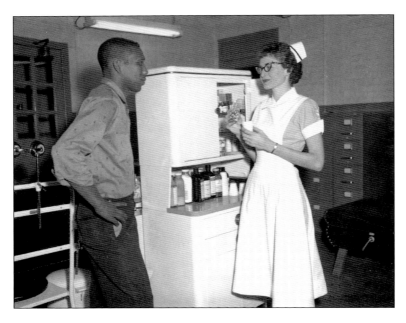

PRESS CLINIC, UNDATED. Employees of the Kingsport Press had access to the medical clinic during all shifts. The clinic was staffed by registered nurses or others trained in first aid. Employees were encouraged to visit the clinic for illnesses or injuries that were not significantly serious. In the event that more care was needed, the press did have physicians under contract.

TRAINING PROGRAM, UNDATED. From the inception of the Kingsport Press, training was critical to the success of the company. The majority of employees started to work untrained but were eager to learn. A vocational school was established, which provided employees with a variety of opportunities for training and apprenticeship. Selma Davenport, Parris Keys, Wanda Wallen Burkes, and an unidentified man seen here were part of the apprenticeship training program.

STRIKE, 1963. On March 11, 1963, the Kingsport Press began one of the longest labor disputes in the nation's history. The management and unions of the Kingsport Press were unable to reach an agreement over wages, benefits, and work conditions. Once negotiations broke down, picket lines went up, and workers went on strike. An estimated 1,600 employees gathered outside the plant on the first day of the strike.

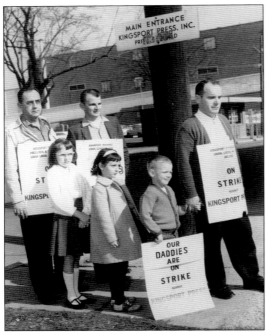

ON STRIKE, 1963. The unions involved in the strike included Kingsport Typographical Union, Local No. 940; Kingsport Electrotypers Union, Local No. 175; Kingsport Machinist Union, Lodge No. 1694; Kingsport Bookbinders Union, Local No. 82; and Kingsport Printing Pressmen & Assistants Union, Local 336. During the strike, these unions together formed the Allied Kingsport Press Unions.

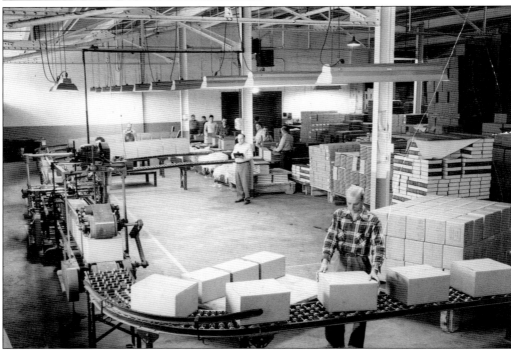

PACKING BOXES, UNDATED. Shortly after the strike began, the Kingsport Press resumed operations with nonunion workers. Tensions ran high between strikers and strikebreakers, also known as scabs. The strike was marred with vandalism and violence. Negotiations between national union officials, labor mediators, press management, and unions continued to be unresolved for four years. The strike ended in the spring of 1967.

CONVEYOR BELT, UNDATED. Edward J. Triebe, the fourth president of the Kingsport Press, led the company through a period of expansion during the 1960s. The expansion included the construction of the Kingsport Press plant in Hawkins County. By 1967, the new plant was in full production. In 1969, Kingsport Press operated three principal facilities in Kingsport, Hawkins County, and Oak Ridge.

ARCATA, UNDATED. In July 1969, the Kingsport Press merged with Arcata National Corporation, the nation's second-largest printing firm. Operating under the same management, Kingsport Press became an autonomous, wholly owned subsidiary. Headquartered in Menlo Park, California, Arcata National Corporation provided printing and information services. The company also managed Arcata Redwood Company, a timber holding and lumber processing operation.

73

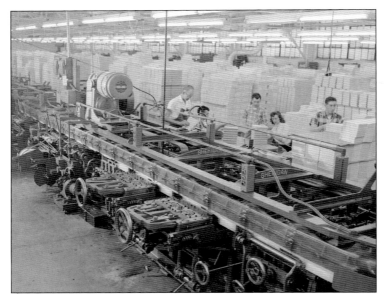

AT WORK, UNDATED. The Kingsport Press was not a publishing house. The company only contracted with publishing houses to print a variety of materials. In the 1970s, the Kingsport Press' principal products included educational materials, reference sets, textbooks, supplementary learning aids, Bibles and religious books, juvenile and adult trade books, and professional and scientific books.

SERVICE AWARDS, 1970. The Kingsport Press held a banquet at Ridgefields Country Club to honor employees that had completed 35 years of service to the company. From left to right, president G. Robert Evans and chairman E.J. Triebe stand with William "Jack" Burnette, vending machine services; Eliza Brooks, bindery's examining and wrapping department; Melvin Mullins, bindery folding department; and John Lee.

Men at Work, Undated. In 1973, Arcata announced plans for a new $2 million warehouse and distribution center in Hawkins County. The new facility was to be the center of shipping operations and would employ around 150 workers. At this time, the Kingsport Press had over 2,500 employees throughout all of its facilities.

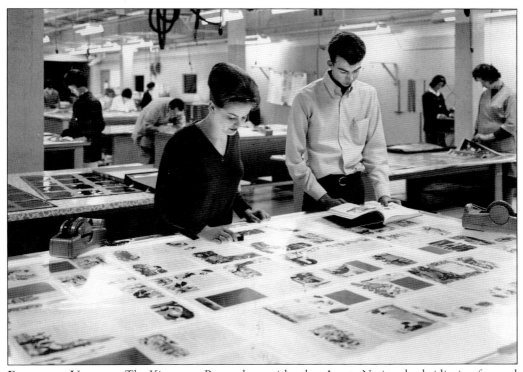

Employees, Undated. The Kingsport Press, along with other Arcata National subsidiaries, focused on collecting, organizing, converting, storing, retrieving, reproducing, and distributing information in a variety of forms. The subsidiaries were grouped into three main units: graphic services, information services, and communications services. In 1985, Arcata National Corporation changed its name to Arcata Graphics.

Employees, Undated. Arcata Graphics was purchased by Quebecor Printing in the 1990s. Through this purchase, Quebecor also acquired the Kingsport Press. Quebecor, founded in 1954 and headquartered in Montreal, Quebec, Canada, was an international printing and communications company. Quebecor Printing merged with World Color Press in 1999, creating Quebecor World.

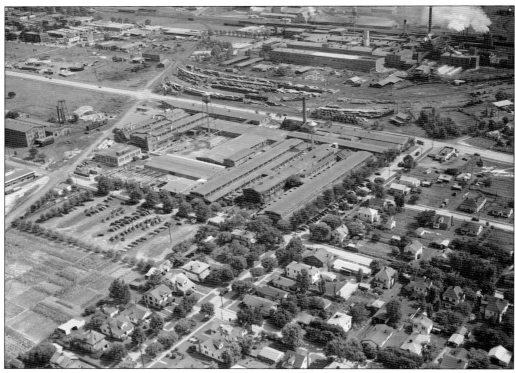

Aerial of plant, Undated. The Kingsport Press closed its Hawkins County plant in 2001 and closed the Kingsport plant in 2006. In 2007, Quebecor donated the Kingsport site, which included the one million square-foot facility and 20 acres of land, to the City of Kingsport. The property was redeveloped and is now home to the Kingsport Farmers Market, the Kingsport Carousel, and various businesses.

Six
Tennessee Eastman and Holston Ordnance Works

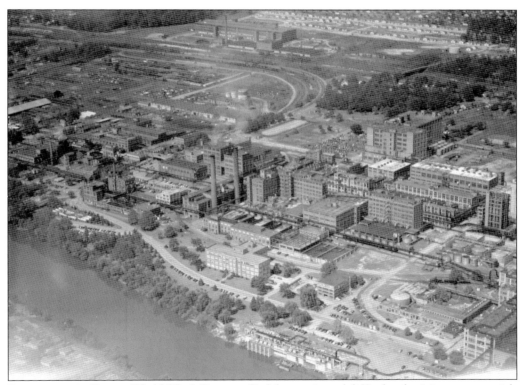

EASTMAN, 1949. During World War I, Eastman Kodak experienced difficulty obtaining raw materials and essential supplies from foreign suppliers. After the war, George Eastman, founder of Eastman Kodak, looked to secure the company's future self-reliance by finding new sources of raw materials that could be owned and managed by the company. After visiting locations throughout the South, Kingsport was chosen. Tennessee Eastman Corporation was officially incorporated on July 17, 1920.

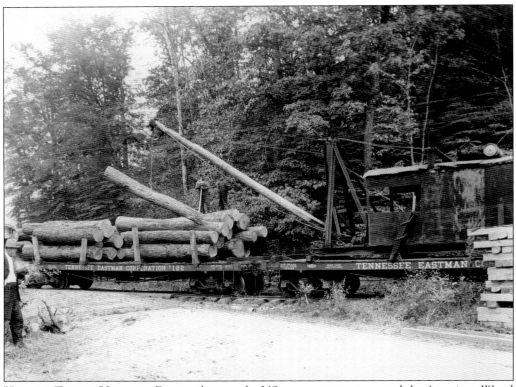

HAULING TIMBER, UNDATED. During the war, the US government contracted the American Wood Reduction Company to build a wood distillation plant to make methanol and related chemicals. The plant was never completed and was abandoned when the war ended. Eastman purchased the 35 acres of land and the factory buildings from the government and later purchased an additional 300 acres to complete the construction the wood distillation plant.

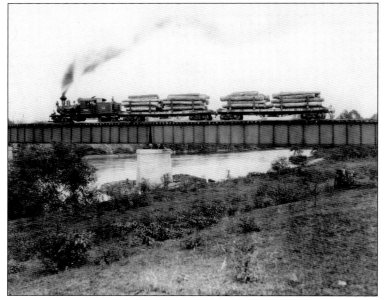

EASTMAN TRAIN, UNDATED. The lumber required to manufacture methanol, also known as wood alcohol, was partially supplied by Eastman's extensive timber lands and timber rights. The company owned over 40,000 acres of land in Tennessee, Virginia, North Carolina, and Kentucky. Local and regional loggers were also contracted to supply lumber for the plant.

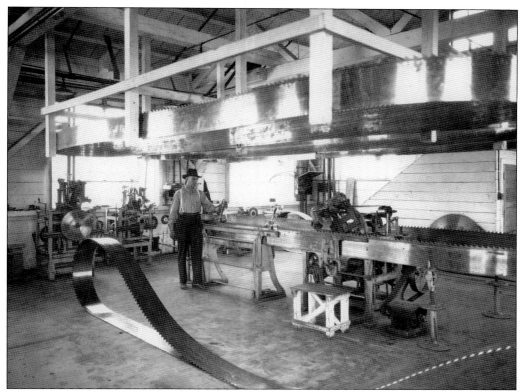

Sawmill, Undated. A band sawmill was established to saw the timber into quality lumber. A lower grade of timber was used to create methanol. In July 1921, the first shipment of methanol was sent to Eastman's plant in Rochester, New York. The wood distillation operations to produce methanol continued until 1945, when methanol could be produced more economically by a synthetic process.

Cutting timber, Undated. Tennessee Eastman expanded production and began marketing the by-products created from the wood distillation process. Some of the by-products included wood preservatives, wood oils, tars, charcoal, and charcoal briquettes marketed as Charkets. Charkets were manufactured by combining charcoal powder and wood tar and sold as cooking and household fuel.

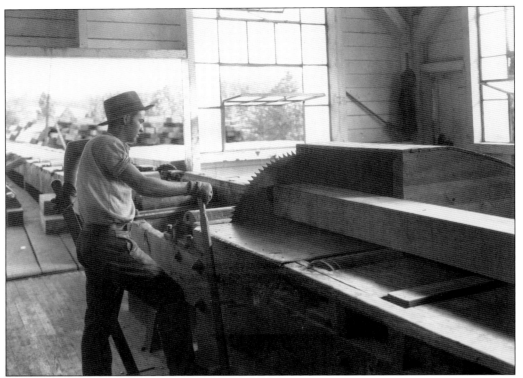

SAWING LUMBER, UNDATED. In 1930, Tennessee Eastman again expanded and began manufacturing cellulose acetate, a key component in making Kodak's safety film. Also at this time, the company began to make acetate yarn and Tenite cellulosic plastics. Tenite, a plastic molding product, was used to make steering wheels, toys, radio parts, poker chips, and a variety of other products. The company also began producing hydroquinone, a chemical used in developing film.

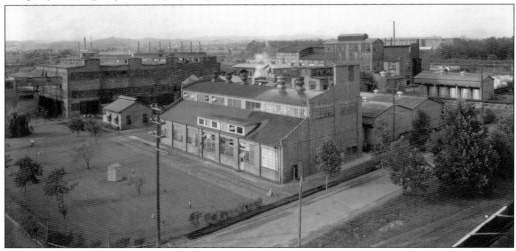

DISTILLATION PLANT, UNDATED. On October 21, 1931, Tennessee Eastman completely shut down operations for two minutes as a tribute to Thomas Edison, inventor of the movie camera, who had died a few days prior. In 1932, with the continued growth of the company, Tennessee Eastman was able to report its first profit since its founding in 1920.

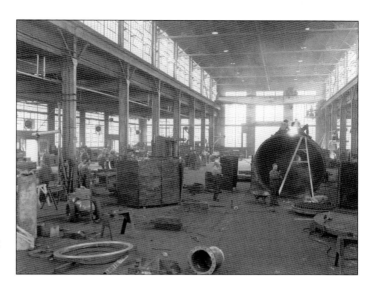

AT WORK, UNDATED. Tennessee Eastman played a significant role during World War II being tasked with operating Holston Ordnance Works where RDX, a powerful explosive, was manufactured. The company was also hired by the Army Corps of Engineers to oversee the operation of the Clinton Engineering Works' Y-12 plant in Oak Ridge. Y-12 was an electromagnetic isotope separation plant that produced enriched uranium for the Manhattan Project.

EMPLOYEES, UNDATED. The Manhattan Project was a research and development project that produced the first atomic bombs. The Manhattan Project was conducted between three sites: Los Alamos, New Mexico; Hanford, Washington; and Oak Ridge, Tennessee. Ground was broken for the Y-12 plant in 1943, and Tennessee Eastman took over management shortly after. Tennessee Eastman engineers, scientists, and other employees were then transferred to Oak Ridge.

EMPLOYEES, UNDATED. The Y-12 facility began operating in November 1943. Some of the equipment was designed with automatic controls that could be operated with limited technical abilities. Very few workers at Y-12 knew what they were producing and were trained not to ask questions. Y-12 produced the enriched uranium used in the atomic bomb, known as "Little Boy," which was dropped on Hiroshima, Japan, on August 6, 1945.

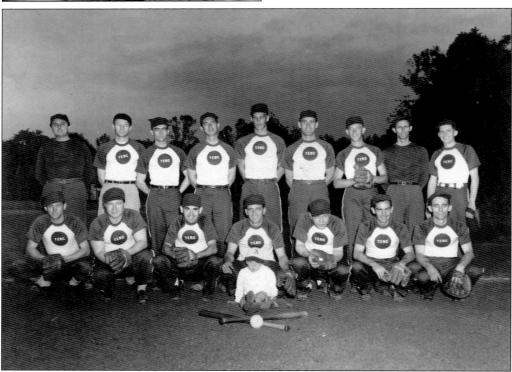

BASEBALL TEAM, UNDATED. Tennessee Eastman, like the majority of industries in Kingsport, had an active recreation department. Bob Delius, or "Purty Bob" as he was known, served as Eastman's first recreation director. Besides athletic activities, there were a variety of recreation clubs for just about anything, including a camera club, radio club, hiking club, and dozens more. They promoted parties, dances, lectures, games, and movies.

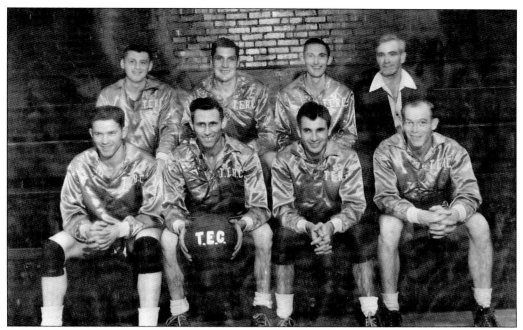

BASKETBALL TEAM, UNDATED. The recreation department sponsored a number of events for employees and their families. One of the most popular clubs for the children of Eastman employees was the Horse Krickers. Bob Delius, the driving force behind the club, named it after Horse Creek, which flowed on Eastman property. Horse Krickers would gather on Saturdays to watch free movies, roller skate, and participate in a variety of activities.

PLANT CONSTRUCTION, UNDATED. In 1945, Tennessee Eastman and Clinton Engineering Works were awarded an Army-Navy Production Award, also known as an "E" Award, for their contributions to the war effort. In 1947, Tennessee Eastman requested to be relieved of its contract with the government to manage Y-12. Operations of the plant were taken over by Carbide and Carbon Chemical Corporation, later known as Union Carbide Nuclear Division.

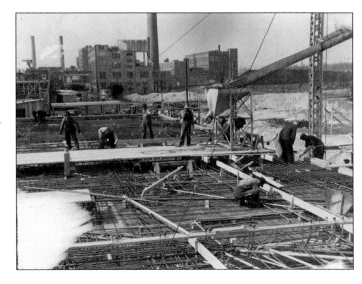

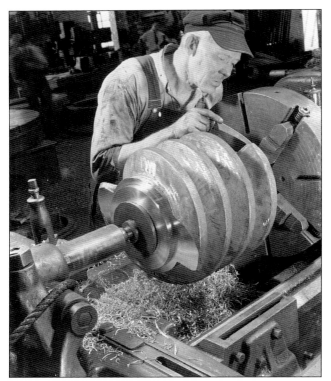

AT WORK, UNDATED. Tennessee Eastman's plant in Kingsport was actively playing its own part in the war effort. The war acted as an impetus for a number of inventions and new uses for already developed products. Tenite Plastic was used to make a number of items from bugles to gas mask parts. With a shortage of rubber, hydroquinone became a vital ingredient to making synthetic rubber.

VICTORY BUS, UNDATED. Employment at Eastman, Holston Ordnance Works and other surrounding plants significantly increased during the war. Employees were coming in on buses that ran for all three shifts from Bristol, Johnson City, Southwest Virginia, and other areas in the region. Employees were encouraged to walk to work or carpool with one another to alleviate traffic congestion.

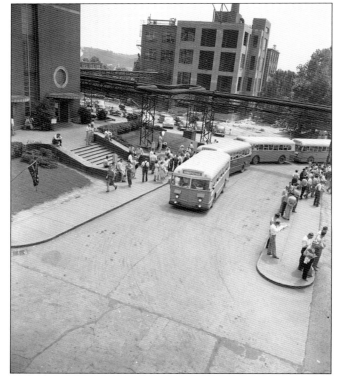

CAFETERIA, UNDATED. With continuous shifts at Eastman, the cafeteria worked overtime supplying meals and coffee to employees of Eastman and Holston Ordnance Works. Around 700 pounds of coffee was served weekly. Recipes were published in the company newsletter, *Tennessee Eastman Company News*. The author of the recipes was originally kept a secret but was later revealed to be H. Von Bramer, a superintendent of the Organic Chemicals Division.

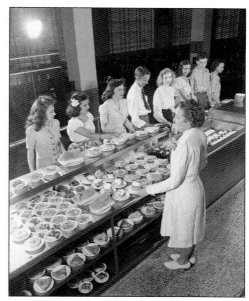

VIEW OF BUILDINGS, UNDATED. In 1942, Eastman Kodak launched the war-born Victory Mail (V-mail) service. V-mail became the primary method of communication between soldiers and their families. Letters on standard stationery were photographed, transferred onto a roll of microfilm, and shipped overseas where the letters would be blown back up to a readable size and printed. The film was made with cellulose acetate and esters manufactured in Kingsport.

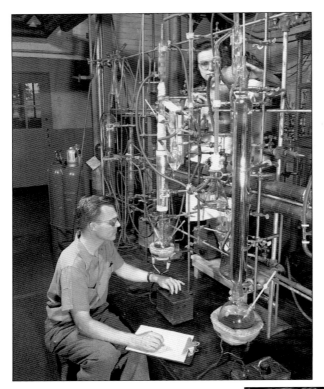

LAB WORK, UNDATED. Tennessee Eastman was awarded its own Army-Navy Production Award for its contributions to the war as a private plant. Only about five percent of companies engaged in war work received this award. Contributing factors for receiving the award included overcoming production obstacles, avoidance of stoppages, effective management, cooperation between management and labor, conservation of materials, maintaining fair labor standards, and good accident, health, and sanitation reports.

EMPLOYEE AT WORK, UNDATED. Eastman expanded operations to a new plant that was built in Longview, Texas. Ground was broken on March 23, 1950. The Texas Eastman Company, located along the Sabine River, primarily produced raw materials used or sold by Tennessee Eastman. In 1953, Eastman Chemical Products was formed to handle all of the sales from Tennessee Eastman and Texas Eastman.

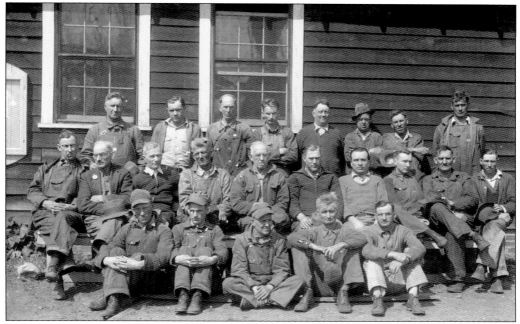

SAWMILL CREW, 1937. The 1950s were a time of significant growth for Tennessee Eastman. In 1951, the company underwent a name change from Tennessee Eastman Corporation to Tennessee Eastman Company. By 1957, Eastman produced around 250 products under three main divisions: fibers, plastics, and chemicals. One of the most lucrative products of that time was cellulose acetate tow, a fibrous material used in cigarette filters.

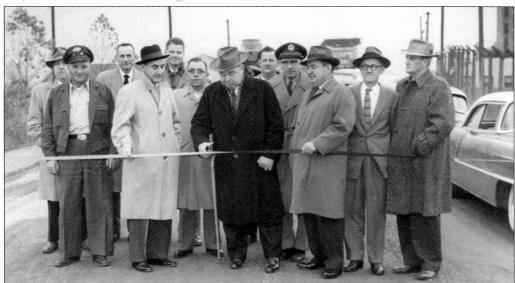

RIBBON CUTTING, 1956. Industry Drive was opened on November 9, 1956, as a bypass that allowed heavy trucks to avoid downtown Kingsport. The ribbon cutting was attended by Herbert G. Stone (center), Wallace Boyd (left), and Mayor Milton Devault (right). Also pictured are A.B. Coleman, C.C. Morrell, Carl Trent, George Stone, Joe Wininger, Gene Bowers, Col. W.J. Scott, T.M. Divine, and D.W. Moulton.

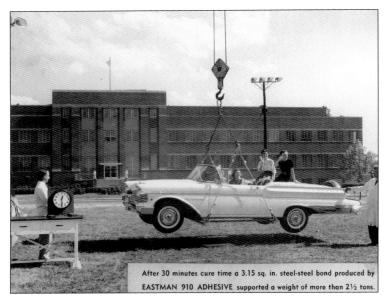

After 30 minutes cure time a 3.15 sq. in. steel-steel bond produced by EASTMAN 910 ADHESIVE supported a weight of more than 2½ tons.

SUPER GLUE DEMONSTRATION, 1957. While experimenting with materials to make clear plastic gun sights, Dr. Harry Coover, Jr. inadvertently discovered what would become Super Glue. The substance he discovered was durable but too sticky. It was not until close to a decade later that it was redesigned as Super Glue, referred to as Eastman No. 910. Super Glue was put on the market in 1958.

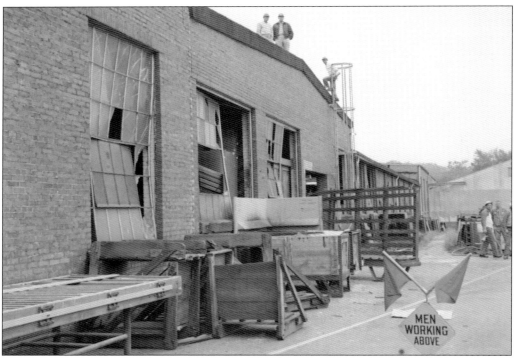

DAMAGED BUILDINGS, 1960. At 4:42 p.m. on October 4, 1960, an unexpected explosion occurred at Tennessee Eastman in the aniline division of the plant. The explosion was the equivalent of six tons of TNT and totally destroyed the aniline plant building and left two huge craters 12 feet deep. The blast was felt all around the city, and even buildings downtown, which are over a mile away, were damaged.

HOSPITAL SCENE, 1960. Sixteen people were killed and hundreds were injured. Crowds gathered at the hospital to donate blood and lend a hand. The victims were Andrew Chadwell, J.W. Sanders, Jess R. Shell, Cornelius Depew, Usif Haney, Arthur H. Stevens, Manze Powers, John Squibb, J.D. Byington, E.O. Repass, Carl Cox, I.D. Mullins, B.C. Arnold, James W. Sage, Carl Cochran, and U.W. Munsey.

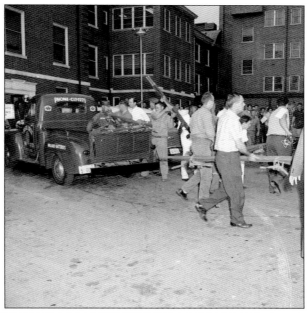

EMPLOYEES, UNDATED. The 1960s continued to be a period of growth for Eastman, and the company expanded to Columbia, South Carolina. The company opened its first manufacturing plant outside of the United States in Workington, England. In the late 1960s, the Eastman Chemicals Division of Eastman Kodak was formed to unify all of Kodak's chemical concerns. This included Tennessee Eastman, Texas Eastman Company, Carolina Eastman Company, and Eastman Chemicals Products Incorporated.

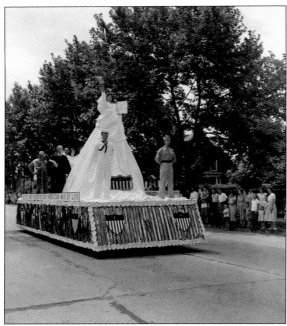

PARADE FLOAT, 1950. The theme of the Tennessee Eastman's Fourth of July parade float was "protect and preserve our American way of life." A number of employees were involved in building and decorating the float. Glen Morehouse, project chairman, was assisted by Walter Rutledge and T.J. Holbert, who helped build the float. C.H. Thompson was the float mechanic, and B.R. Sells was the driver of the float.

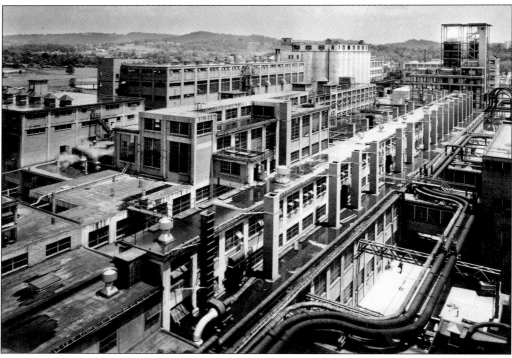

CELLULOSE ESTERS DIVISION, C. 1950. In June 1983, Tennessee Eastman opened the first commercial coal gasification facility in the United States. Prompted by the oil embargoes of the 1970s, the plant was designed to use coal, rather than petroleum, as a raw material in the commercial production of industrial chemicals. In 1995, the "chemicals from coal facility" was recognized as a National Historic Chemical Landmark by the American Chemical Society.

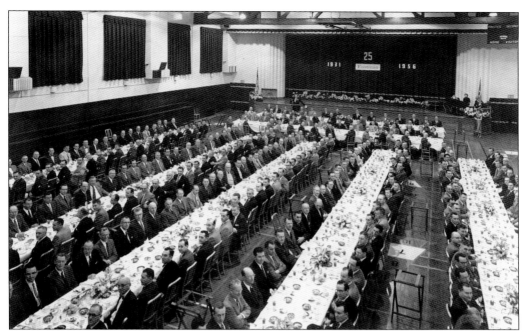

BANQUET, 1956. In 1993, Eastman Chemical Company received the Malcolm Baldrige Award. The award, given by the president of the United States, is the highest recognition of performance excellence in both public and private organizations. The award, first presented in 1988, was named after the Reagan administration commerce secretary Malcolm Baldrige, who died in 1987.

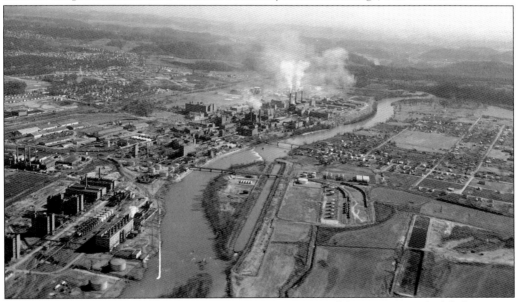

VIEW OF PLANT, UNDATED. In 1994, Tennessee Eastman spun off from Eastman Kodak, becoming an independent corporation. With a name change to Eastman Chemical Company, the company became the 10th-largest chemical company in the United States and the 34th largest in the world. Started as a subsidiary of Eastman Kodak, Tennessee Eastman had diversified into other products, and Kodak accounted for less than 10 percent of its sales.

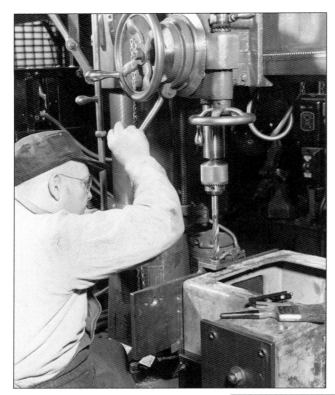

Eastman Worker, Undated. Since Tennessee Eastman was founded in 1920, hundreds of diversified products have been in production. Some of the more well-known products throughout the company's history include Tenite plastic, Kodapak polyester, Kodel Polyester fiber, Chromspun, Tenox, and Eastman Tritan. The chemicals, fibers, and plastics produced at Eastman can be found in thousands of products from food and beverage packaging, pharmaceuticals, medical supplies, paint, and fabrics.

Employee Clinic, Undated. Once a subsidiary of Kodak, Eastman Chemical Company became an independent leading global manufacturer with locations around the world. The company continued to grow with the acquisitions of Hercules in 2011, Solutia in 2012, and Taminco in 2014. Headquartered in Kingsport, Eastman Chemical Company still produces a wide range of materials.

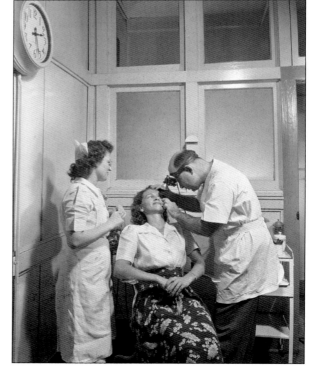

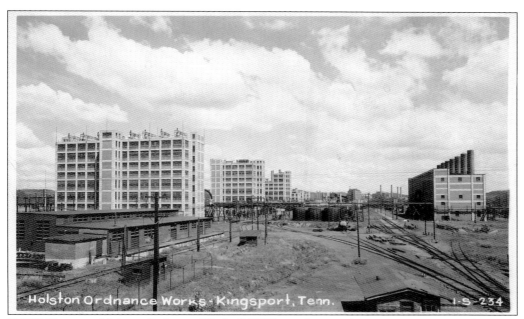

HOW, UNDATED. Holston Ordnance Works (HOW) was the site of a major wartime manufacturing plant that played a critical role in the Allied victory during World War II. The plant was part of the US World War II Ordnance Department's GOCO (government-owned, contractor-operated) industrial program. HOW manufactured the explosive RDX (Research Development Explosive), a substance that changed the trajectory of the war.

EMPLOYEES, 1952. First used in Germany in 1899, RDX was deemed too dangerous and too expensive to produce. Scientists working at the Woolwich Arsenal in England in the 1930s discovered that adding TNT and beeswax to RDX made the compound less volatile. The final product was called Composition B. When aluminum was added to Composition B, it created Torpex, an underwater explosive that helped win the Battle of the Atlantic.

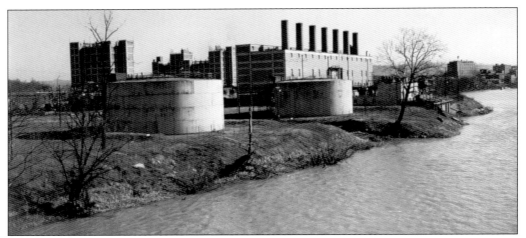

AREA A, 1946. The Woolwich Arsenal had successfully created RDX, the most powerful explosive to exist prior to the atom bomb, but it could only produce it in small batches. In 1941, the British government asked the United States for assistance in manufacturing the explosives in large quantities. In turn, the US government asked Tennessee Eastman to manufacture RDX.

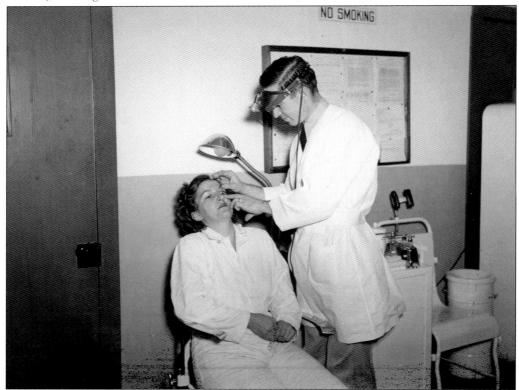

CLINIC, UNDATED. Though Eastman primarily produced photography materials and supplies, the same chemicals could also be used to manufacture RDX. The supply of chemicals and the familiarity of handling them made Eastman the ideal choice to produce these explosives. Eastman quickly set up two pilot plants: The Wexler Bend Pilot Plant made RDX, and the Horse Creek Pilot Plant made Composition B. The plants were connected by an interplant railroad system.

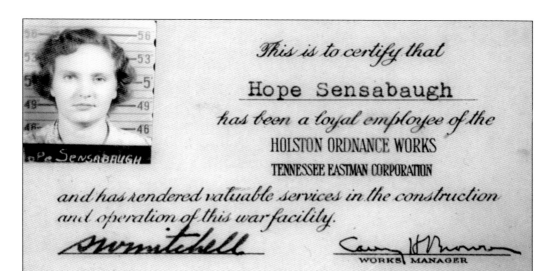

HOW Employee, Undated. Eastman's research and development at its pilot plants were so highly successful that construction on Holston Ordnance Works began immediately. By the spring of 1943, the number of construction workers peaked at over 16,000. The influx of people created a major housing shortage. The mayor at the time, Glen Bruce, created the Emergency Housing Authority in an effort to improve matters related to the shortage.

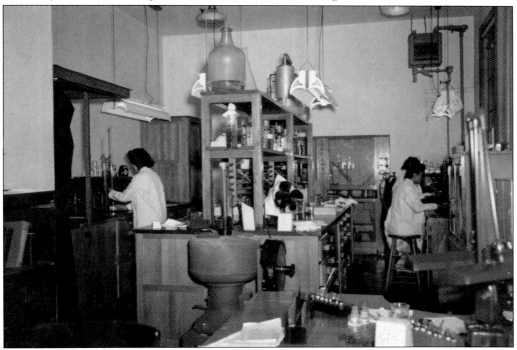

Women in Lab, Undated. Mayor Bruce, along with the Kingsport Merchant's Association, organized the City Housing Program in 1942. The first order of business of the group was to conduct a house-by-house survey to determine the location and status of available rental space in the area. Residents were urged to rent out any space available in their homes, even double renting beds and spaces for shift workers.

TRAILER CAMP, 1942. In October 1942, the Federal Office of Price Administration issued a decree regarding rent control for certain areas essential to the war effort, which included Kingsport. In an effort to alleviate the lack of housing, a government trailer camp was built to house war workers. Located in downtown Kingsport, the camp covered a six-block area that included Market, Main, Cherokee, and Wexler Streets.

TRAILERS, 1942. Each trailer in the camp was equipped with lights, a gas cooking stove, a kerosene heater, tables, chairs, and a bed. At one point the trailer camp consisted of over 200 trailers. After the war some of the trailers were transferred to Clinton Engineering Works in Oak Ridge and the rest went to Pascagoula, Mississippi. Another trailer camp was established years later to house veterans and their families.

UNIDENTIFIED MAN WITH JOHN STILES (LEFT), UNDATED. In 1942, the government took over Rotherwood Mansion and around 6,000 acres in Hawkins County for the construction of HOW. Authorized by the war department, the land began at the bridge, extended down the Holston River, and included the Rotherwood Dairy Farm. Lt. Col. W.E. Ryan, commanding officer of HOW, and his wife took up residency at Rotherwood Mansion.

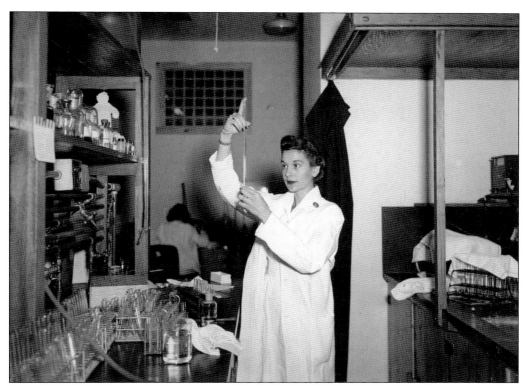

WOMAN IN LAB, UNDATED. Following the war, Rotherwood was declared surplus property and deeded back to John B. Dennis. Dennis, in return, sold the Rotherwood Mansion and property to Herb Stone and his wife, Marguerite. With the end of World War II, the production lines of RDX were shut down, and a massive layoff began. The plant was on standby status from 1946 to 1949.

AREA B, 1951. During the war, a large number of women entered the workforce, and this was the case at HOW. Due to the lack of available men during wartime, women were needed for positions typically employed by men. Originally hired for mainly office and clerical jobs, women began working in the laboratories testing chemicals and explosives and working the production lines.

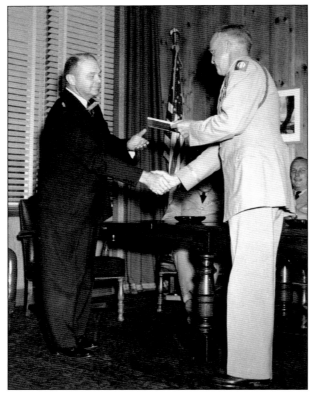

H.G. STONE, 1948. As the works manager of HOW, H.G. "Herb" Stone (left), played a key role in the development of RDX. Stone began working at Tennessee Eastman in 1927, became works manager in 1941, and in 1942, he took over operations at HOW. Following the war, Stone was presented with the President's Certificate, then the highest civilian award for work in the national defense program.

GUARD INSPECTION, 1951. Lt. Col. William J. Scott (left), commanding officer of HOW, and plant manager W.H. Zugschwerdt (right) are seen inspecting the Holston Defense guard unit. Security was critical. Employees and visitors were required to have passes. Automobiles were checked for items like matches and lighters, which were restricted. The plant was surrounded by miles of fencing and guard towers. Guards patrolled the grounds in cars and motorcycles and on horseback.

GUARDS, 1951. Safety at the plant was critical when dealing with the chemicals and explosives. Floors had to be kept wet, and the production line workers were issued special clothing that could only be worn at work. Workers had to bathe after every shift and have their clothes washed in the plant laundry service to make sure that no one left the plant contaminated by RDX.

EMPLOYEES, UNDATED. With the end of World War II, production of RDX at HOW shut down, and the plant was put on a "stand-by" status from 1946 to 1949. Then, in 1949, the plant was reactivated as Holston Defense Corporation (HDC). HDC was awarded a contract by the government to operate the plant on a small-scale basis for research and development. During the Korean War, the plant continued manufacturing RDX.

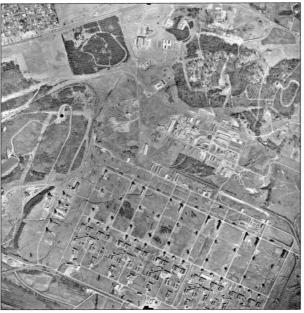

HOW AERIAL, UNDATED. After the Korean War, production slowed until the Vietnam War when the plant began manufacturing High Melt Exposulve (HDX) and RDX. In the 1960s, the plant's name was changed to Holston Army Ammunition Plant. BAE Systems became the operating contractor of the plant in 1999. The Holston Army Ammunition Plant continues to manufacture a full range of products for the Department of Defense and the Department of Energy.

Seven

FOOD AND BEVERAGE INDUSTRY

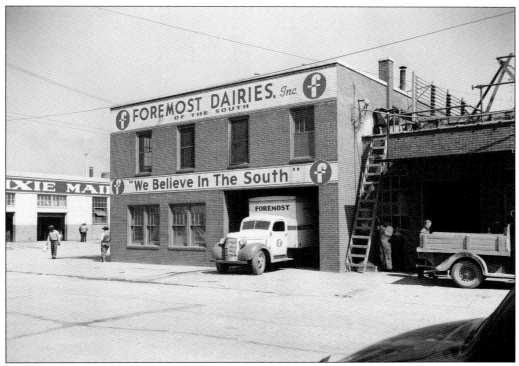

FOREMOST DAIRIES, 1946. Foremost Dairies, located on the corner of Market and Cherokee Streets in downtown Kingsport, was part of Foremost Dairies of the South. The Kingsport plant opened in 1943 and sold milk, ice cream, butter, and a variety of other dairy products and prided itself on the lab-controlled excellence and purity of its products. The company was also known for the "churn fresh flavor" of its buttermilk.

EMPLOYEE OF FOREMOST DAIRIES, 1947. Foremost Dairies got its start in the early 1930s in Florida under the direction of Paul Reinhold, a pioneer in modern ice-cream manufacturing. Reinhold founded the Reinhold Ice Cream Company in 1916 in Oakmont, Pennsylvania. In 1930, he began using an industrial refrigeration technique that was considered the first of its kind in the nation.

FOREMOST EMPLOYEE, 1950. In 1931, Reinhold was approached by J.C. Penney and asked to direct a dairy and ice-cream operation in Florida called Foremost Dairies. Foremost Dairies was named in honor of Penney's prized bull named Foremost. Foremost would grow from a small operation primarily serving the southern United States into an international conglomerate.

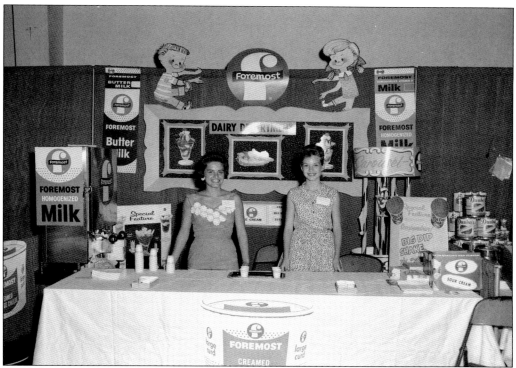

FOREMOST DAIRIES BOOTH, 1960. Foremost Dairies were huge advocates for dairy farms throughout the South. The company maintained a number of cooperative agreements with milk producers in the area so it could distribute milk year-round. The company accepted graded and ungraded milk from its suppliers. The company sold and distributed its products to retail consumers, stores, restaurants, and other miscellaneous outlets.

BASKETBALL TEAM, UNDATED. Foremost played a leading role in the development of the dairy industry in the region. In 1967, Foremost merged with Pinemont Farms though they continued to operate as separate organizations and make their own product lines. In 1968, Foremost Dairies of Kingsport was changed to Farmbest, and operations were moved to Bristol.

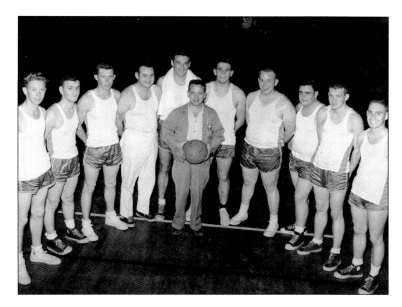

SOUTHERN MAID, 1951. The Southern Maid Dairy Products Corporation was started in 1922 as the Southern Ice Cream Company and manufactured ice and ice cream. In 1924, the company consolidated with the Chapin and Sacks Company, and in 1928, a plant on the corner of Market and Cherokee Streets in downtown Kingsport was opened. The plant was built by local contractors, Armstrong, Purkey, and McCoy.

SOUTHERN MAID EMPLOYEES, 1951. Southern Maid operated other plants in the region. The Kingsport plant was limited to the production and dispensing of ice cream, ice, fountain supplies, and syrups. Southern Maid could produce 3,000 gallons of ice cream a month. The motto of the company was "a dish of ice cream is a dish of health." The company was consolidated with Foremost Dairies in 1952.

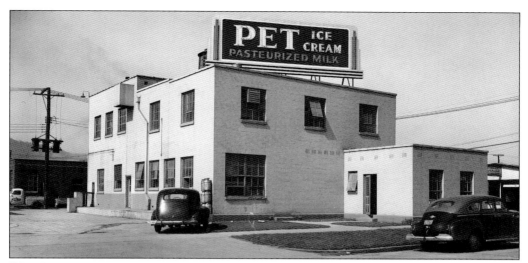

PET Dairy Products, 1946. PET Dairy Products celebrated a formal opening on July 26, 1930, that was attended by over 6,000 people. Visitors were treated to a tour of the facility, going from department to department and learning about the equipment and the processes of the plant's operation. The plant was located on the corner of Clay and Market Streets.

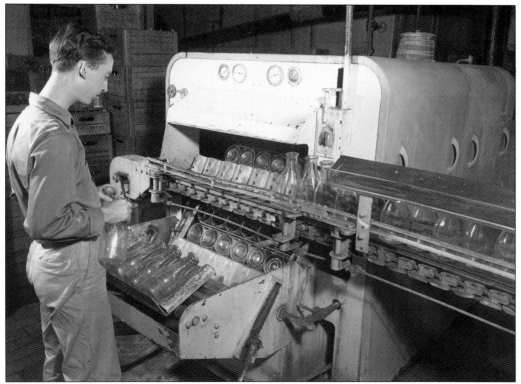

PET Employee, 1953. PET sold milk, buttermilk, chocolate milk, cream, cheese, cottage cheese, and ice cream. The company was one of the main suppliers of dairy products to local businesses. PET had a daily capacity of 2,000 gallons of milk and 2,000 gallons of ice cream. It also had buttermilk that "tastes as good as that you used to get from the old-fashioned cedar churn."

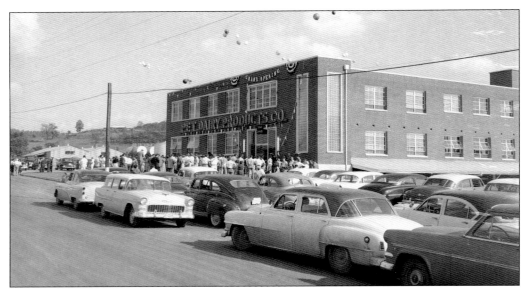

KONNAROCK ROAD, 1955. PET Dairy moved to its location on Konnarock Road, near the intersection of East Sevier Street, in 1955. According to an advertisement in the *Kingsport Times*, the official grand opening of the new plant was at 4:00 p.m. on Thursday, September 29, 1955. The company offered three days of open house for the community to visit and tour the new plant.

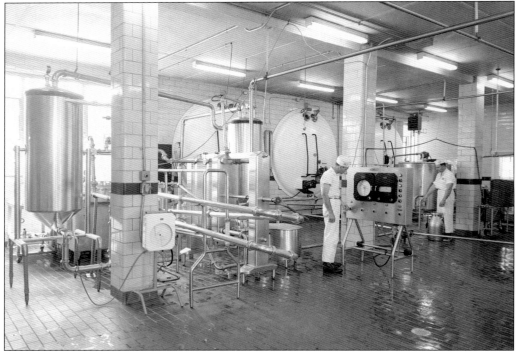

PET DAIRY EMPLOYEES, 1963. Products produced by PET Dairy expanded to a variety of products, including butter, eggnog, half and half, heavy cream, and flavored drinks. The company continued to provide products throughout East Tennessee, Southwest Virginia, and Western North Carolina. This photograph shows employees within the interior of the plant.

PET Dairy Employee, 1963. For several decades, the company continued to provide products throughout East Tennessee, Southwest Virginia, and Western North Carolina. PET Dairy became part of the dairy group under the Dean Foods Umbrella when Suiza Foods merged with Dean Foods in 2001. Dean Foods was headquartered in Texas.

PET Dairy Team, 1958. After close to 80 years in Kingsport, PET Dairy closed its doors and ceased operations in September 2009. Around 120 jobs were lost when the plant closed. Production was moved to Kingsport to other facilities within the Dean Foods Company. At that time, Dean Foods, a food and beverage company, was the largest dairy company in the United States.

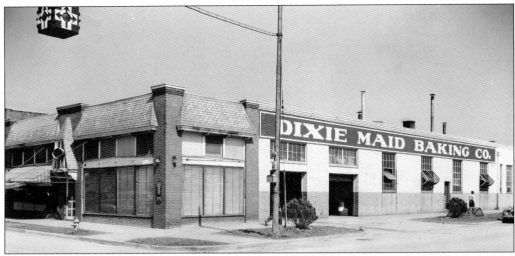

DIXIE MAID, 1946. The Dixie Maid Baking Company opened in Kingsport in March 1938 and was located on the corner of Cherokee and Market Streets. Dixie Maid originated through Haun's Home Bakery as the original maker of Dixie Maid Bread. Lee R. Drury came to Kingsport from Lexington, Kentucky, to take over management of the company. Eventually, he became co-owners with Denzil S. Sample.

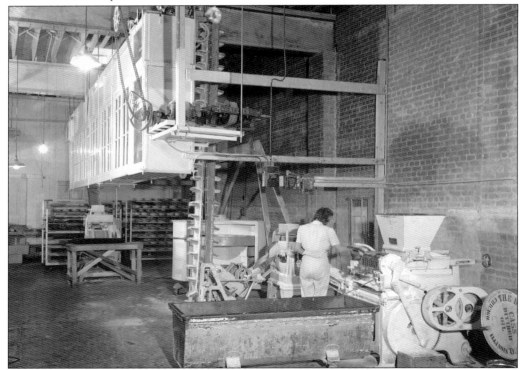

DIXIE MAID BAKERY, 1946. Dixie Maid sold retail and wholesale baked goods. The bakery was equipped with two oil-burning ovens, one for bread and rolls and the other for cakes and pies. Dixie Maid baked wedding and party cakes and made a popular layer cake that the company sold in its storefront. The bakery operated the oven for 12 hours each day.

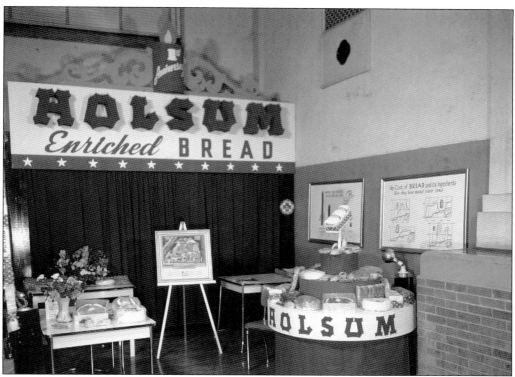

HOLSUM BREAD, UNDATED. In 1947, the Dixie Maid Baking Company began distributing a new product called Holsum Bread. The new product allowed for the company to expand the number of delivery drivers and trucks to cover a radius of about 40 miles. The delivery area included Johnson City, Bristol, and Rogersville, Tennessee, and Dungannon, Virginia. The Holsum Bread motto was "Don't say bread, say 'Holsum.'"

BASKETBALL TEAM, UNDATED. Holsum Bread was fairly popular and was the exclusive bread choice for many local restaurants and stores. The Holsum basketball team played their first city basketball league game in January 1951. At that time, the city basketball league had seven teams in the men's league and four in the women's league.

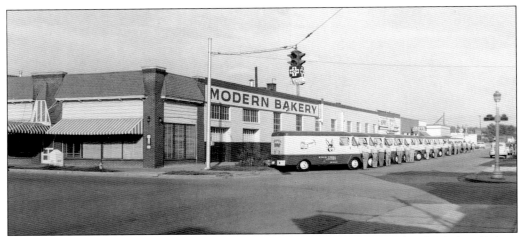

MODERN BAKERY BUILDING, UNDATED. Dixie Maid Baking Company merged with Modern Bakery in May 1955. The Modern Bakery, with home offices in Harlan, Kentucky, underwent a thorough modernization process throughout the bakery building. The new equipment allowed for another expansion for the company, and it was able to increase the number of employees.

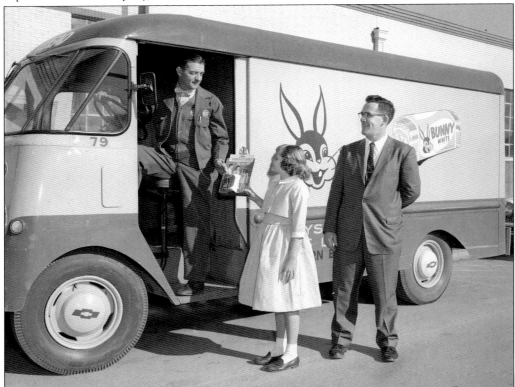

BUNNY BREAD, 1956. Bunny Bread was created by Jack Lewis Sr. in Anna, Illinois, in 1947. In 1954, Lewis sold the rights to the American Bakers Cooperative to expand the distribution of Bunny Bread. Modern Bakery began distributing Bunny Bread around Kingsport in the mid-1950s. In this photograph, a Bunny Bread delivery driver stopped his truck to pose for this March of Dimes promotional photograph.

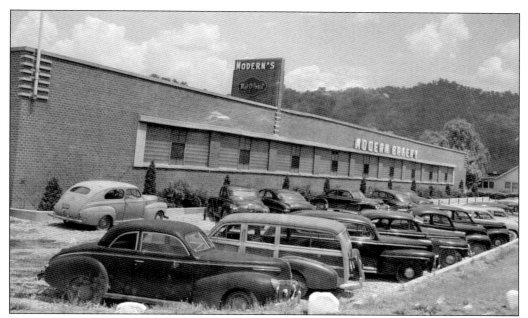

MODERN BAKERY, 1950. In 1962, the Modern Bakery Company purchased a 16-acre plot on B Street to build a new plant and expand the company's operations. The company served outlets in Tennessee, Virginia, and Kentucky. The goal of the expansion was to be able to increase business in more states.

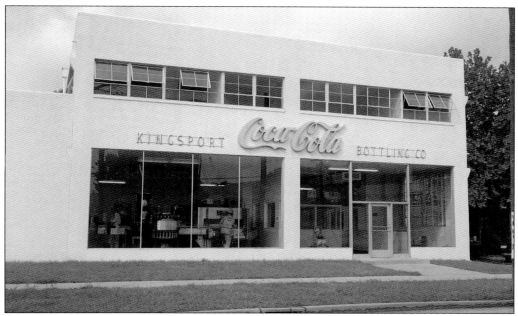

COCA-COLA BOTTLING WORKS, 1951. The Coca-Cola Bottling Works of Johnson City opened a branch plant in Kingsport in 1951. The plant was located on West Sullivan Street and operated until 1970. Other carbonated beverage bottling companies in Kingsport at one time or another included Nehi Bottling Works, Nesbitt-Fleenor Bottling Company, Holston Bottling, Julep Bottling, and Kingsport Chero-Cola Company.

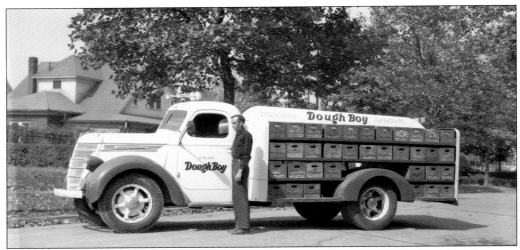

DOUGHBOY, 1946. Cheer-Up Doughboy Bottlers was incorporated on April 16, 1942. The plant was located in a building on West New Street that had been occupied by the Holston Bottling Company. The company bottled Cheer-Up, a lithiated lemon soda by the Cheer-Up Sales Company, and Smile, an orange soda produced by the Smile Company. Along with Cheer-Up and Smile, it bottled Doughboy Cola from the Doughboy Beverage Corporation of Pittsburgh, Pennsylvania.

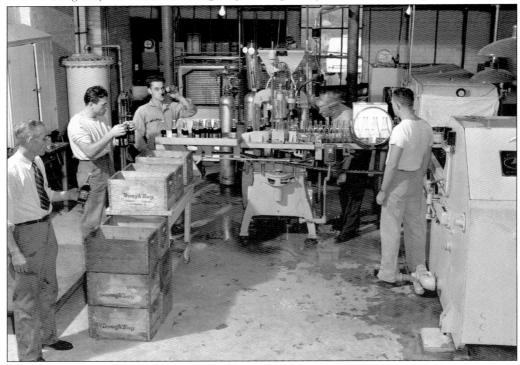

BOTTLING PLANT, 1946. Other varieties of soda bottled at the plant were Dream Orange, Yankee Doodle Root Beer, and Uncle Dud's. Uncle Dud's was named after Dudley "Doughboy" Hewette, president of the company. In 1945, the company changed its name to Beverages Incorporated, and an overhaul of the plant was initiated. The expansion of the plant included all new equipment and was touted as "Kingsport's first all automatic bottling plant."

Eight

OTHER DIVERSIFIED INDUSTRIES

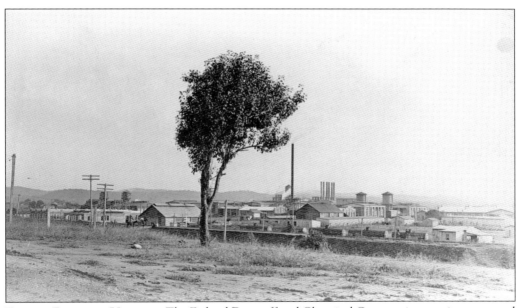

FEDERAL DYESTUFF, UNDATED. The Federal Dyestuff and Chemical Corporation was incorporated in October 1915. The company purchased 200 acres of land between the railroad and the Holston River to build the plant. The company was built during World War I when there was a demand for high explosives. At one time, the company employed around 1,000 men and 35 chemists, making it one of the largest employers in Kingsport.

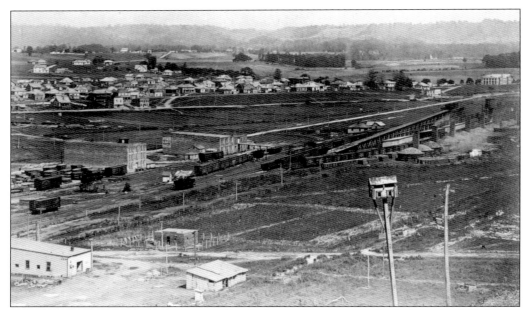

THE FEDERAL CLUB, 1917. Federal Dyestuff and Chemical Corporation built the Federal Club, seen in the far right of this image, for employees of the company. The club had recreational facilities, including tennis courts. It later operated as a hotel under a succession of names—Union Hotel, Southern Hotel, Hotel Borden, and Blue Ridge Hotel—until it was converted into apartments. It was torn down in 1975.

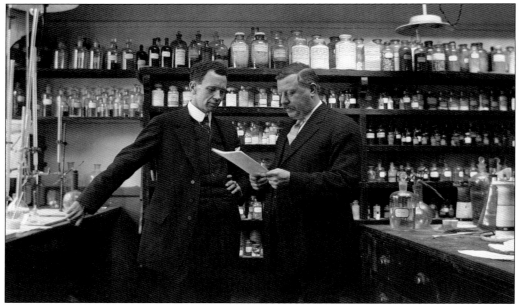

EMPLOYEES OF FEDERAL DYESTUFF, UNDATED. After the war, the demand for products made by the Federal Dyestuff plant decreased. The company ceased operations and was dismantled in 1918. In that same year, the company was purchased by Union Dye and Chemical Corporation. In 1921, it went bankrupt and was sold at auction to Kingsport Color Corporation. The Kingsport Color Corporation, makers of bleaching materials, dissolved in 1925, and all assets were sold off.

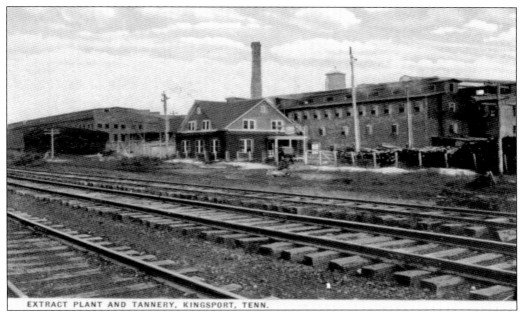

Kingsport Extract and Tannery, Undated. Kingsport Extract and Tannery plant opened in 1912 and started producing leather goods and extracting tannin from chestnut wood. In 1925, the tannery had a daily capacity of 400 hides, a portion of which were manufactured into belting. The extract plant was equipped to produce 140 barrels of liquid tanning extract per day.

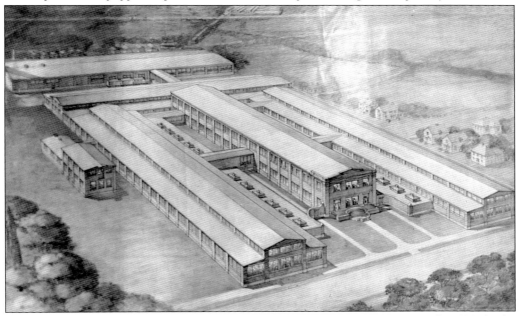

Sketch of Plant, Undated. Grant Leather Corporation of Kingsport was organized in 1919 by the Simmons Hardware Company of St. Louis. The company purchased the holdings of the Kingsport Extract Plant and Tannery as well as 12 acres of adjoining land for the purpose of consolidating the buildings with the new plant. The company manufactured leather goods such as saddles, harnesses, and belting from the raw stages to finished products.

HOMESTEAD HOTEL, UNDATED. The Homestead Hotel, built in 1919 by the Grant Leather Company, served as a clubhouse for employees and executives of the company. The clubhouse had 85 rooms and operated its own cafeteria. The building was located on the corner of Sullivan and Clay Streets. It was later remodeled into a hotel and housed guests for several decades. The Homestead Hotel was torn down in the 1990s.

SLIP-NOT BELTING CORPORATION, 1951. Originally part of the Grant Leather Company, the Slip-Not Belting Corporation became a separate entity in 1924. The company was founded by H. Jefferson Shivell, who had come to Kingsport in 1919 to work at Grant Leather. The company operated a small plant on Clay Street until 1934, when it moved to Main Street. Until 1935, the company exclusively manufactured leather.

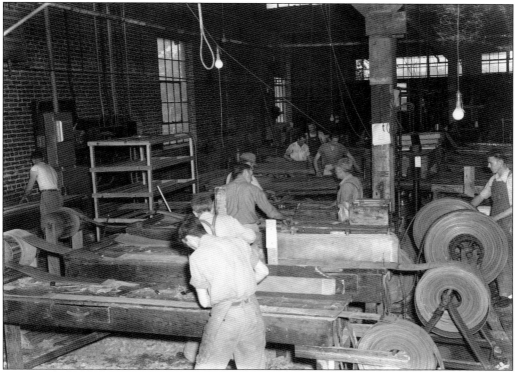

EMPLOYEES AT WORK, 1948. In the 1940s, the Slip-Not Corporation built a tannery on Horse Creek Road and began production of various types of leather for the textile industries. The company provided its various products to textile, chemical, brick, cement, explosive, paper mill, and other manufacturing industries. A subsidiary of Slip-Not, Jefferson Sales Corporation, was formed in 1952. Jefferson Sales sold pumping and irrigation equipment and electric tools.

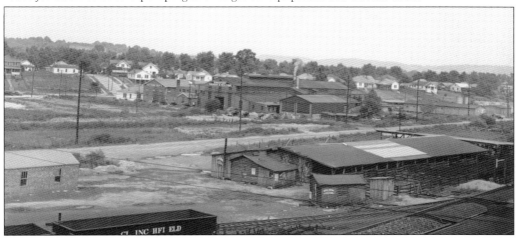

FOUNDRY BUILDINGS, 1946. The Kingsport Foundry and Manufacturing Corporation began operation in 1927. W.E. Ring (president and manager), J.G. Vaugh (vice president and assistant manager), and J. Luther Blunts (treasurer), formerly of the Pulaski Foundry Manufacturing Corporation in Pulaski, Virginia, came to Kingsport to head up the new business. Along with the foundry, the plant operated its own pattern and machine shop.

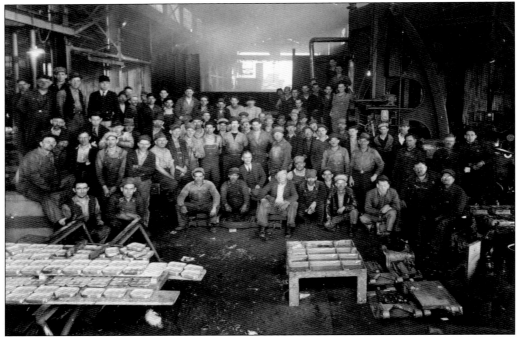

FOUNDRY EMPLOYEES, UNDATED. Employees of the Kingsport Foundry and Manufacturing Corporation pose for a photograph at the plant in this undated image. The plant, located on East Sullivan Street, was originally designed to produce heavy processing castings for the chemical industry. Later, it began working with nickel, bronze, and aluminum castings. The foundry had special furnaces for melting non-ferrous metals and alloys.

CITIZENS SUPPLY CORPORATION, UNDATED. The Citizens Supply Corporation was founded in June 1915 with two wagons and one team of mules. The charter officials included Charles and Harvey Brooks. Harvey had come to Kingsport from Rogersville in 1913 to join his brother Charles at Citizens Supply Corporation. The company was located along the Carolina, Clinchfield & Ohio Railroad tracks on the corner of Main and Cherokee Streets.

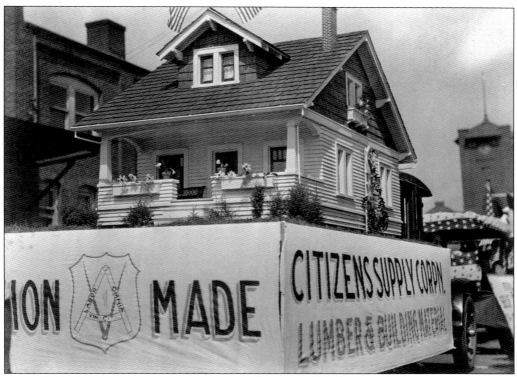

CITIZENS PARADE FLOAT, UNDATED. Citizens Supply provided building materials to approximately 75 percent of all of the structures within Kingsport's corporate limits. The Citizens Supply Corporation's motto was "If its to build with, we have it." Harvey Brooks and Charles Brooks were prominent citizens and helped considerably in the development of Kingsport. Brooks Circle was named after the brothers.

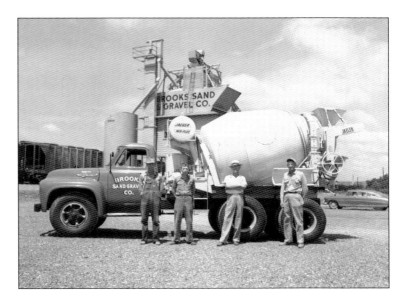

BROOKS SAND AND GRAVEL, 1953. In the early 1920s, Harvey Brooks founded the Brooks Sand and Gravel Company. The company merged with Vulcan Materials in 1958. Harvey Brooks and his wife, Ruth (Haire) Brooks, built Allandale Mansion, commonly known as the "White House of Kingsport." Upon his death in 1969, Harvey Brooks gifted Allandale to the City of Kingsport.

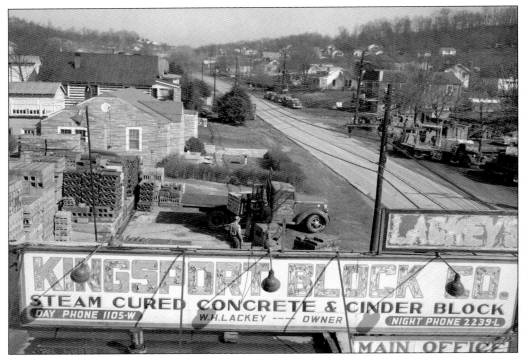

CONCRETE EXAMPLES OF QUALITY, 1951. Lackey's Kingsport Block Company, located on the Lynn Garden-Gate City Highway, was opened around 1945 by W.H. Lackey. The company made sand, cinders, concrete, drain tile, cinder blocks, cinder bricks, and concrete blocks. In 1952, it was purchased by C.I. Compton and Fred H. Smith. The company began manufacturing and distributing materials such as ranch stone, ranch block, hydro-stem cured block, and Roman stone.

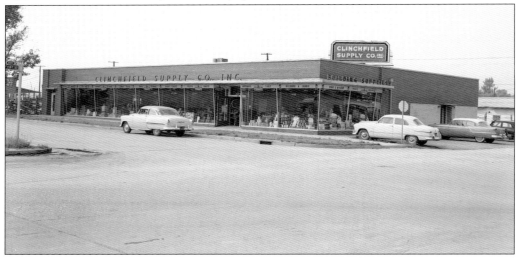

CLINCHFIELD SUPPLY, 1954. The Clinchfield Supply Company opened for business in 1945. Located at the corner of East Market and Wexler Streets, the company was managed by Robert "Bobby" Peters. A graduate of Dobyns-Bennett High School, Peters went on to be a standout football player for Princeton University before returning to Kingsport. Peters also served several terms as a Tennessee state senator. The company slogan was "There's a Material Difference."

UNION SUPPLY, 1946. The Union Supply Company, located at 620 East Sullivan Street, was organized in 1929 as the Union Coal and Supply Company. The company had a complete stock of building supplies with the motto "Where the home begins." The company was owned by James P. Bray Jr. and Henderson Nickels Horsley. In 1949, Bray retired, and Horsley became the sole owner, and the name was changed to Horsley Lumber.

HORSLEY LUMBER, 1964. Henderson Nickels Horsley, owner of Horsley Lumber, came to Kingsport in 1924 and opened the City Coal Company. He operated that company for several years before becoming a partner in the Union Supply Company. When Henderson Horsley died in 1962, the company was reorganized with William J. Horsley as owner and operator. Horsley Lumber was located on East Sullivan Street.

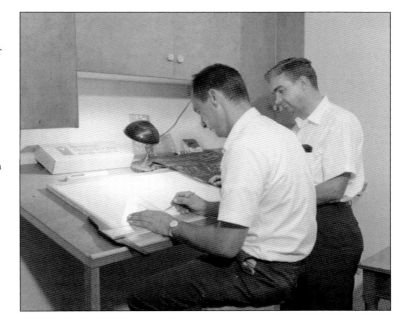

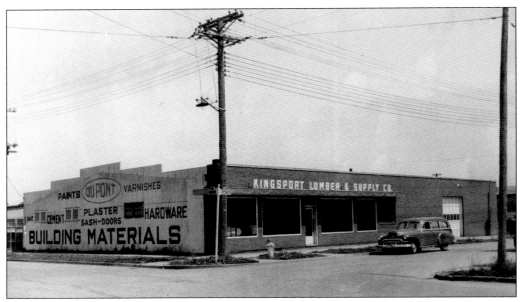

KINGSPORT LUMBER AND SUPPLY COMPANY, UNDATED. The Kingsport Lumber and Supply Company opened in 1931 after buying out the entire stock and equipment from the Poarch Brothers Lumber Company. Poarch Brothers opened in 1925 on the corner of Clay and Main Streets. Kingsport Lumber and Supply Company had a full line of building materials and served East Tennessee and Southwest Virginia.

SUN WARM, UNDATED. Sun Warm Incorporated of Kingsport was formed in 1951 by Francis T. "Dink" Walsh, who came to Kingsport in 1944. Sun Warm focused on electric radiant heating cables known as ceiling heat that once installed were invisible under the ceiling plaster and could distribute heat evenly. The tagline in its advertising was "Fill homes with indoor sunshine." The company was unincorporated in 1987.

SOUTHERN OXYGEN, UNDATED. This image shows a city recreation league basketball team that was sponsored by the Southern Oxygen Company. In 1935, it was announced that a plant was being built for making acetylene and oxygen by the Southern Oxygen Company of Washington, DC. The plant's principal use was welding and cutting operations. Southern Oxygen supplied businesses and industries within a 200-mile radius of Kingsport.

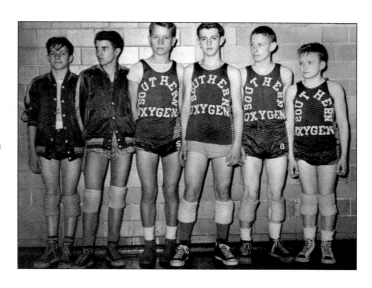

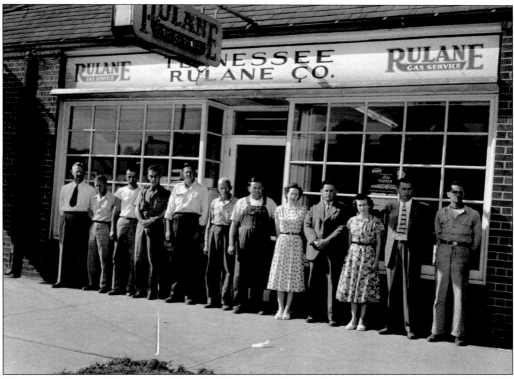

TENNESSEE RULANE COMPANY, 1949. The Tennessee Rulane Company was incorporated in 1944 when the Rulane Gas Company purchased the Blue Flame Gas Company, and the companies merged. Rulane, liquified gas, was first used in Kingsport in 1933 and was widely used in Kingsport for lighting, heating, cooking, and refrigeration. The company provided bottled gas that came in returnable cylinders and tank gas that was deposited in underground tanks.

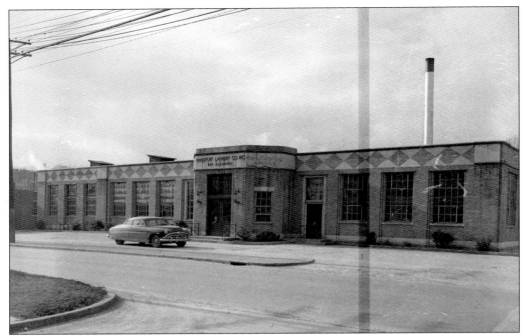

KINGSPORT LAUNDRY COMPANY, 1952. The Kingsport Laundry Company moved into this building on West Sullivan Street in 1937. Prior to that, it was located on the corner of Market and Commerce Streets. The West Sullivan Street building was designed by local architect Allen Dryden Sr. The commercial laundry handled laundry for families and hotel and industrial services and offered full-service dry cleaning.

HOWARD-DUCKETT, 1946. Lee L. Duckett and S.B. Howard began operating the Howard-Duckett Company in 1926. The company, located at 206 East Charlemont Avenue, provided publishing, printing, and lithography services. The plant operated within about a 100-mile radius of Kingsport. In 1930, S.B. Howard sold his interests in the company to Lee L. Duckett. In 1931, B.M. Hagen and Gordon Hughes became associated with the company.

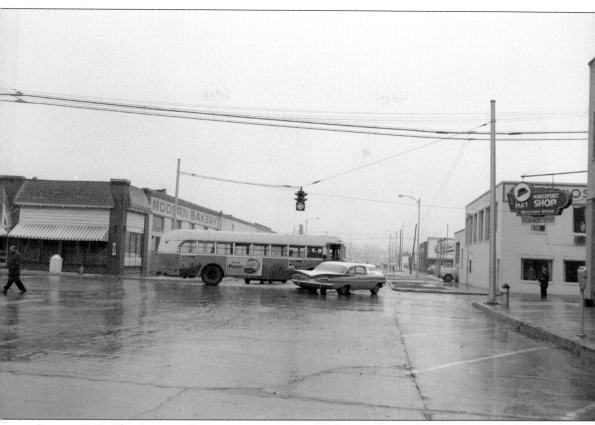

SIGNAL, 1961. The Arroway Company, organized in 1935, manufactured a new patented electric traffic signal invented by R.O. Ferguson. Prior to a plant opening in Kingsport in 1937, the signals were manufactured in Detroit. The plant was located in Highland Park on property owned by Dr. Will Hutchins. The first signal, at the corner of Market and Cherokee Streets, was installed in 1938. Arroway filed for bankruptcy in 1939.

BIBLIOGRAPHY

Bryant, William A. *A Brief Survey of Industrial Plants in Kingsport Tennessee with Emphasis on the Geographical Locations of the Industrial Workers.* Johnson City, TN: East Tennessee State College, 1951.

Egan, Martha Avaleen. "Kingsport Press." Tennessee Encyclopedia of History and Culture. Ed. Carroll Van West. Tennessee Historical Society and Rutledge Hill Press, 1998.

Long, Howard. *Kingsport: A Romance of Industry.* Kingsport, TN: The Sevier Press, 1928.

Rotary Club of Kingsport. *Kingsport: City of Industries, Schools, Churches, and Homes.* Kingsport, TN: Kingsport Press, 1937.

Rotary Club of Kingsport. *Kingsport: Past, Present, and Future.* Kingsport, TN: Rotary Club of Kingsport, 1977.

Rotary Club of Kingsport. *Kingsport, Tennessee: A Modern American City developed through industry.* Kingsport, TN: Rotary Club of Kingsport, 1962.

Rotary Club of Kingsport. *Kingsport, Tennessee: Excellence & Opportunity.* Kingsport, TN: Rotary Club of Kingsport, 1998.

Rotary Club of Kingsport. *Kingsport, Tennessee: The Planned Industrial City.* Kingsport, TN: Rotary Club of Kingsport, 1951.

Rotary Club of Kingsport. *Kingsport: Today's Proud Heritage.* Kingsport, TN: Rotary Club of Kingsport, 1986.

Lay, Elery A. *An Industrial and Commercial History of the Tri-Cities in Tennessee-Virginia.* Kingsport, TN: Lay Publications, 1982.

Rauber, Earle L. "Kingsport: An Industry Pattern." Monthly Review, Federal Reserve Bank of Atlanta. Atlanta, Georgia, August 31, 1945, volume XXX, No. 8, pages 81–87.

Smith, Walter Forest. *Bookmakers To America.* Kingsport, TN: Kingsport Press, 1948.

Wolfe, Margaret Ripley. *Kingsport, Tennessee: A Planned American City.* Lexington, KY: University Press of Kentucky, 1987.

NEWSPAPERS
Kingsport Times
Kingsport Times News
Kingsport News
Knoxville News Sentinel

COMPANY NEWSLETTERS
Mead Messenger
News Piper
Press Piper
Tennessee Eastman News

ABOUT THE ARCHIVES

The Archives of the City of Kingsport collects, preserves, houses, and makes accessible records pertaining to the history of Kingsport. The archives work to preserve the documentary heritage of Kingsport and its inhabitants. The Friends of the Archives (FOA) is a nonprofit support group that aids in promoting the interests of the archives.

Discover Thousands of Local History Books Featuring Millions of Vintage Images

Arcadia Publishing, the leading local history publisher in the United States, is committed to making history accessible and meaningful through publishing books that celebrate and preserve the heritage of America's people and places.

Find more books like this at
www.arcadiapublishing.com

Search for your hometown history, your old stomping grounds, and even your favorite sports team.

Consistent with our mission to preserve history on a local level, this book was printed in South Carolina on American-made paper and manufactured entirely in the United States. Products carrying the accredited Forest Stewardship Council (FSC) label are printed on 100 percent FSC-certified paper.